contents

a wall . a door . a tree . a lightbulb . winter

sørlandets kunstmuseum january 15 - april 11 2021

Ugo Rondinone was born 1964 in Brunnen, Switzerland. After moving to Zürich to work with the Austrian multi-media artist Hermann Nitsch, he felt compelled to study at the Hochschule für Angewandte Kunst in Vienna. Upon his graduation in 1990, Ugo maintained an incredible work rate. A definitive move to New York, in 1998, further forging his artistic prowess. Following the positive response to his early concentric circular paintings, Rondinone started to explore other mediums and installation processes. A beautiful and hauntingly poetic togetherness with the incredible poet John Giorno, who sadly passed away in 2019, spanning over 20 years, deeply fueled the intricate variety and depth of the works Ugo develops.

Rondinone's wide-ranging practice utilizes metaphoric and iconographic images such as clouds, animals and figures, as well as powerful declarative sayings. His work is often founded on themes and motifs from our everyday surroundings (light bulbs, masks, trees, etc.) that acquire a poetic dimension by being isolated, repeated or given specific material treatments. With respect to their form, his installations contain diverse references found within the history of art and popular culture.

A well-known recent work in this respective is «Seven Magic Mountains» placed in the expansive desert-lands of Nevada, USA. The installation is comprised of playfully stacked rocks coated in a special highly artificial looking coat of weather resilient day-glo paint. Imagine all hues of the rainbow paired with more subdued blacks and greys. Ugo noted the connection between these natural stones and their applied «new exterior» shapes a continuum 'between human and nature, artificial and natural, then and now.

ugo

rondinone

winter

spring

summer

fall

The contrast between the works shown at SKMU could not be higher nor more intentional. The exhibition will feature four selected large-scale works, that underline another important element to RONDINONE's work: understatement. These naturally crafted objects, that exist on their own, without applied narrative, exist as bare poetic objects free for the onlooker to discover. The work «All Absolute Abyss» forms the leitmotif to this showing, an oversized wooden (portal), crafted with sturdy applied hardware and enamel. The door summons and beckons us; are we inside, what lies beyond, is it open, ajar or firmly shut.

Together with the other works shown here; questions of belonging, of space, of nature, of interior and exterior, of fantasy, of desire and togetherness are evoked. The quiet room transports the onlooker into a secluded space, free from distracting societal noise and torrential (digital) information. Instead we are allowed to be silent. The works simply exist as they are, made with wonderful attention to detail, allowing the audience to experience them in their own respective ways. This rather melancholic world ensures that the boundaries between reality and dreamworld fade. What remains is a deeply personal suspension of time. The rest is darkness.

Marlo Saalmink

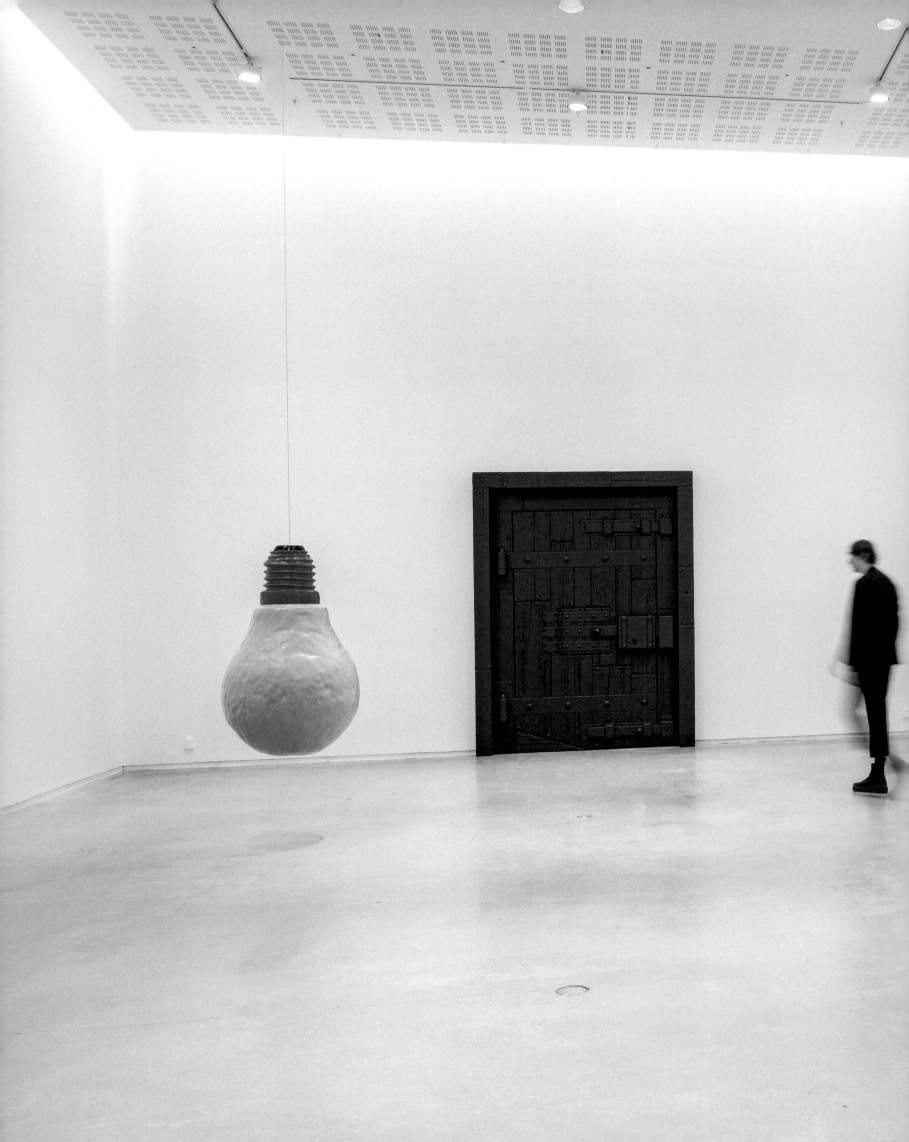

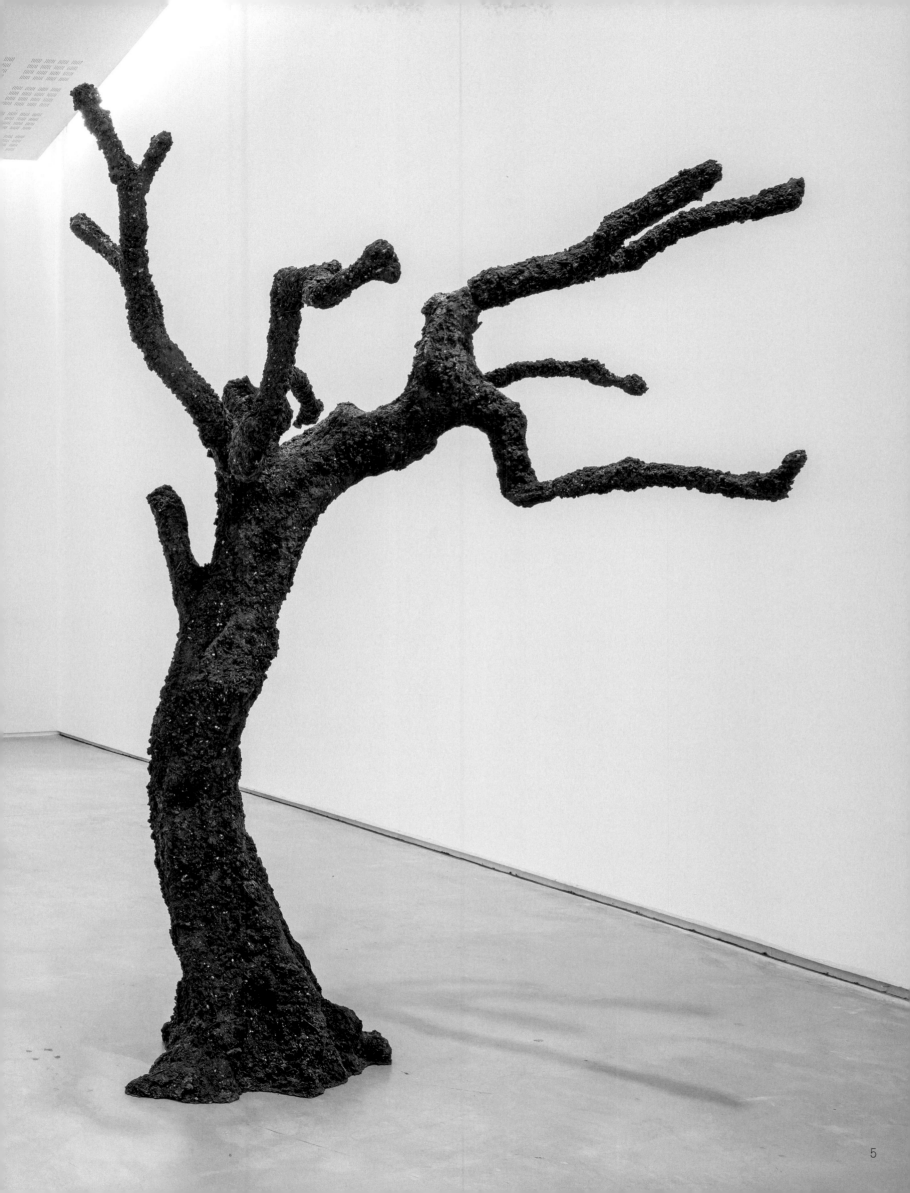

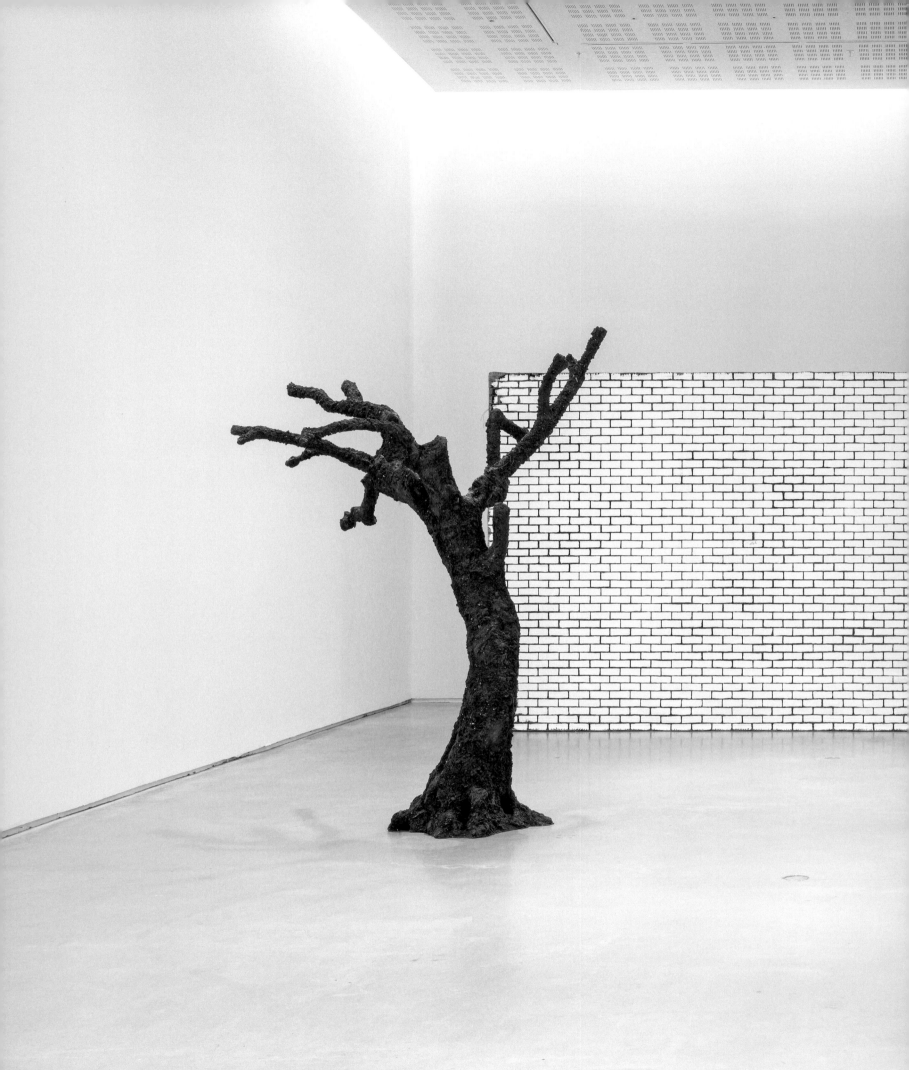

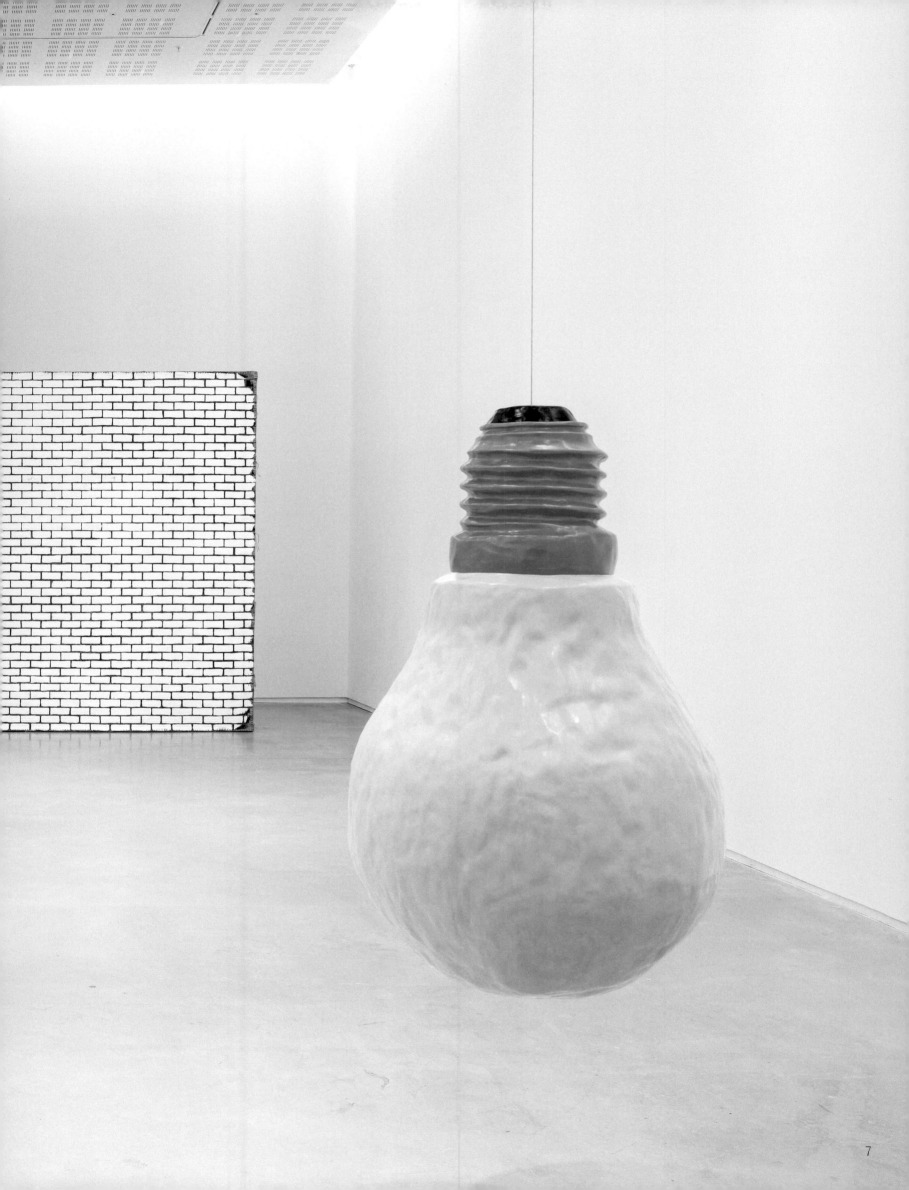

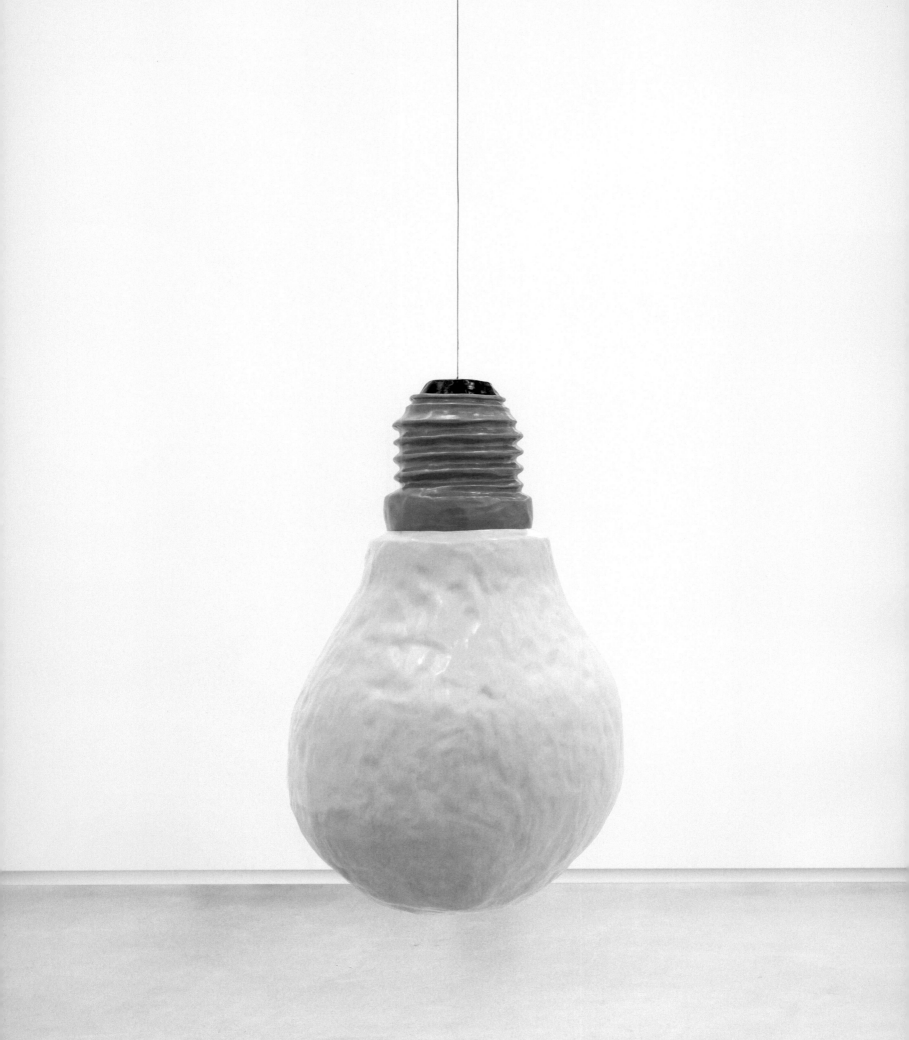

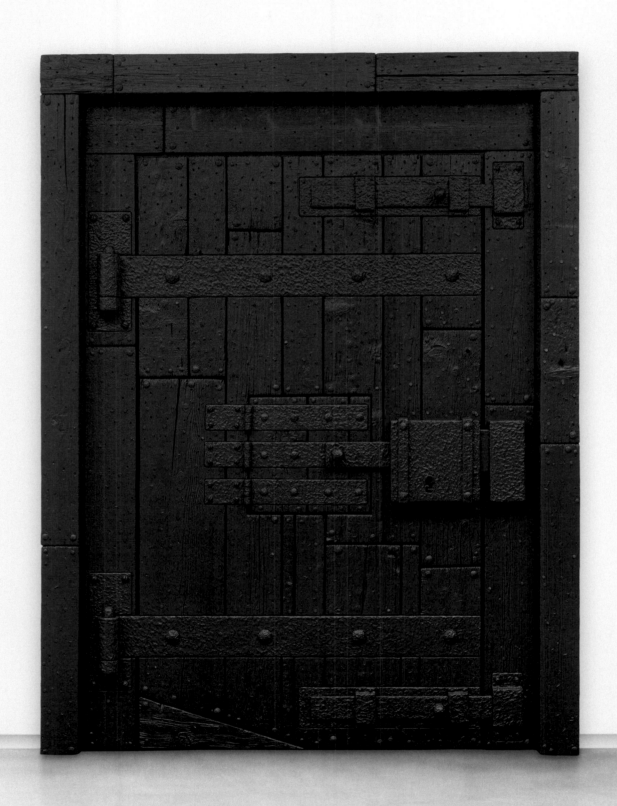

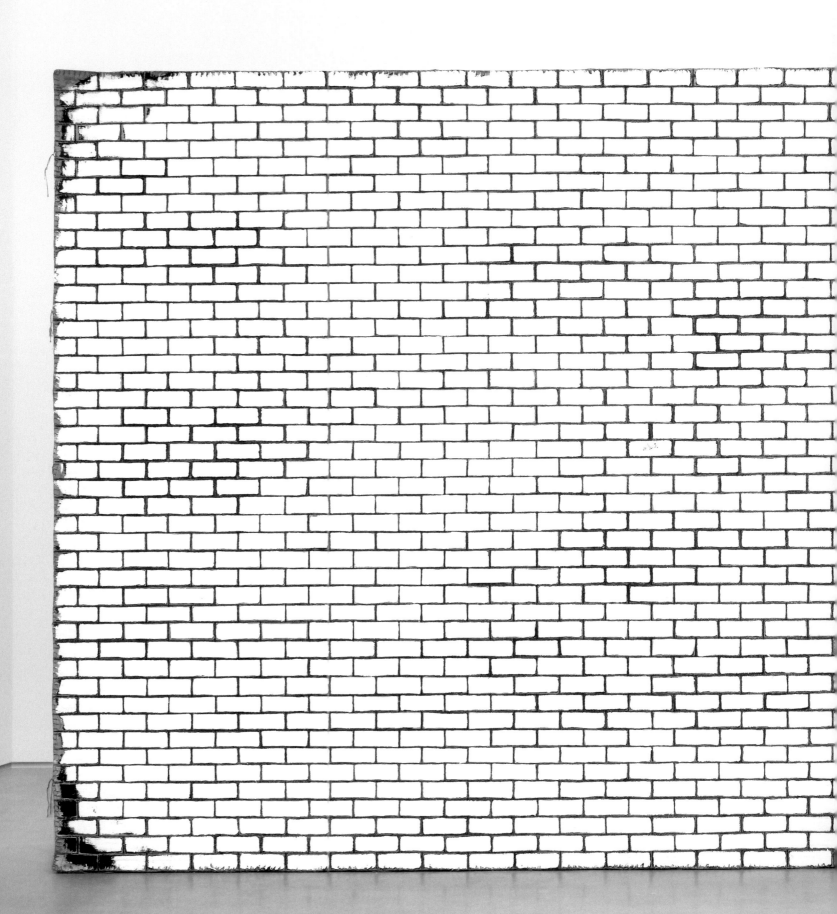

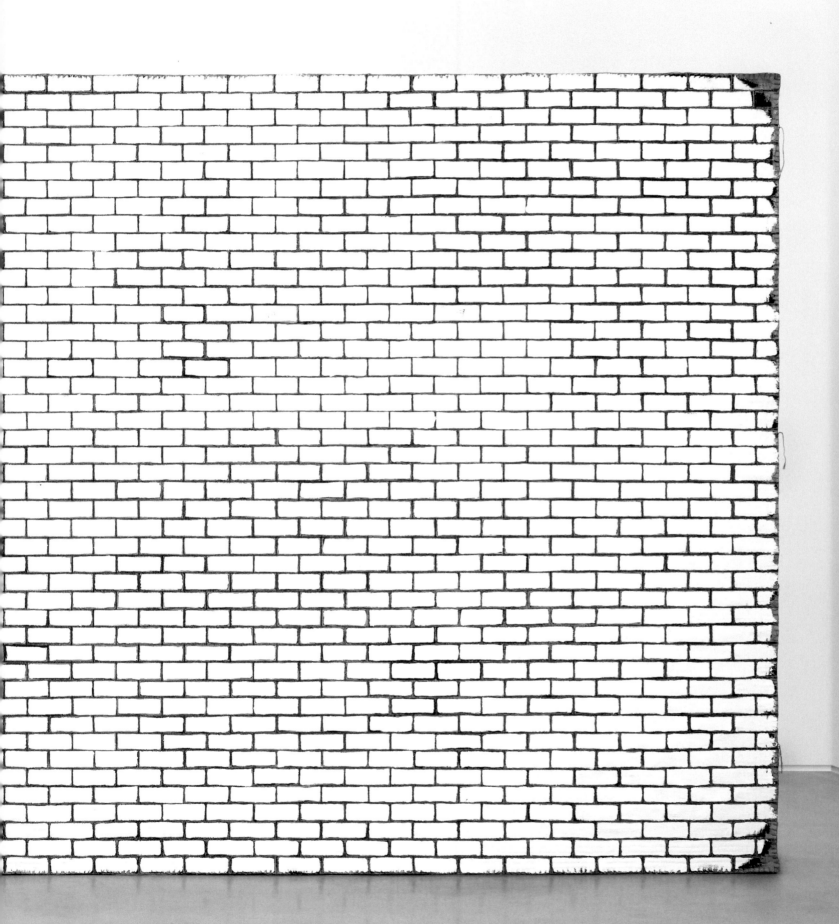

a sky . a sea . distant mountains . horses . spring

sadie coles hq april 12 - may 22 2021

The title of the exhibition a sky . a sea . distant mountains . horses . spring . reads simultaneously as a stage direction and a checklist of archetypes that take into account the watery, fluctuating state of life as it is lived, complete with the fullest range of emotions, desires and dreams. As in dreams, they are visible signs for something invisible. Taken together, they define the intersection of symbolism and spirituality.

<div align="right">Ugo Rondinone, 2021</div>

The spring exhibition at Sadie Coles HQ features new sculptures and paintings by Ugo Rondinone, in which the artist, continuously inspired by the natural world, animates profane subjects like horses, the sea, and the sky to become vessels of spiritual contemplation. Marking the end of lockdown, the exhibition – which spans both London galleries – articulates themes of time, nature, renewal and the psyche, both in its individual parts and as an eclectic whole.

At Kingly Street, Rondinone presents fifteen new sculptures of horses cast from blue glass. Slightly smaller than life size, each sculpture is formed from two distinct shades of transparent blue – bisected horizontally to suggest a horizon line running through the silhouette of the animal. The contained form of the horse thereby becomes a vessel for a seascape or landscape, an ethereal frame as well as a corporeal representation. Rondinone reverses the traditional formula of a body in a landscape, transposing the 'landscape' into the confines of a body in order to imply a microcosmic world. By multiplying the concept across fifteen foal-sized sculptures, he also creates a larger – three-dimensional – landscape of repeating forms.

Rondinone's horse sculptures embody ideas of space, time and nature that have recurred throughout his work over three decades. Each object suggests a compound of the four elements – water, air, earth (connoted by the body of the horse), and fire, crystallised in the substance of the fired glass. The capsule-like, sealed form of the horse is countered by its intimation of boundless space. Each sculpture moreover projects itself outwards, beyond its glass confines, by casting blue light across the gallery. In this way, the sculptures are prisms that alter the space around them – creating a 'lightscape' of shifting blues. Within this environment,

the viewer's own physical presence – vertical, opaque and mobile by contrast with the phantasmal horses – is thrown into relief.

The conjunction of sea and sky is the subject of a painting in the rear of the gallery, in which a rising or sinking sun (or moon) is depicted looming beyond a horizon line. The simple collocation of elements – conveyed through washes of watercolour on canvas – recalls the schematic designs of Rondinone's various long-running series of paintings, whether his 'Horizons' comprised of tiered horizonal lines, or his 'Suns' of concentric circles. In a further echo of his earlier practice, the painting's title is a compound word referencing the date of its completion. Timelessness is annexed with a precise date, and the painting is framed as a mental space to be entered into.

At Davies Street, Rondinone is showing four multipart paintings that reinvent his long-running Mountain sculptures in two dimensions. Each painting collapses the formula of stacked, painted rocks into three shaped canvases – arranged vertically and painted in single brilliant hues. The paintings restage an ambiguity – between sculpted form and painterly surface – that was central to the Mountain sculptures. The contoured outline of each canvas (suggestive of a monolithic volume) is offset by the flatness of its pigmentation – oil paint has been applied rapidly, in broad strokes, to the gesso-rendered surface.

In their hard, bright surfaces, Rondinone's new Mountain paintings are the opposite of his new watercolours, in which the pigment sinks in multiple layers into the fabric support. Upstairs, a cycle of smaller watercolours repeat and multiply the form of a celestial body hovering over a tranquil sea – their varying colours evoking a panoply of sunrises and sunsets, or rising or plunging moons. Collectively, the paintings express a dualism of diurnal time (the twenty-four cycle) and cosmic time. They also perhaps suggest the capacity for these separate magnitudes to blur together, capturing the way in which – as Virginia Woolf observed – "An hour once it lodges in the queer element of the human spirit may be stretched to fifty or a hundred times its clock length; on the other hand, an hour may be accurately represented on the timepiece of the mind by one second."

James Cahill

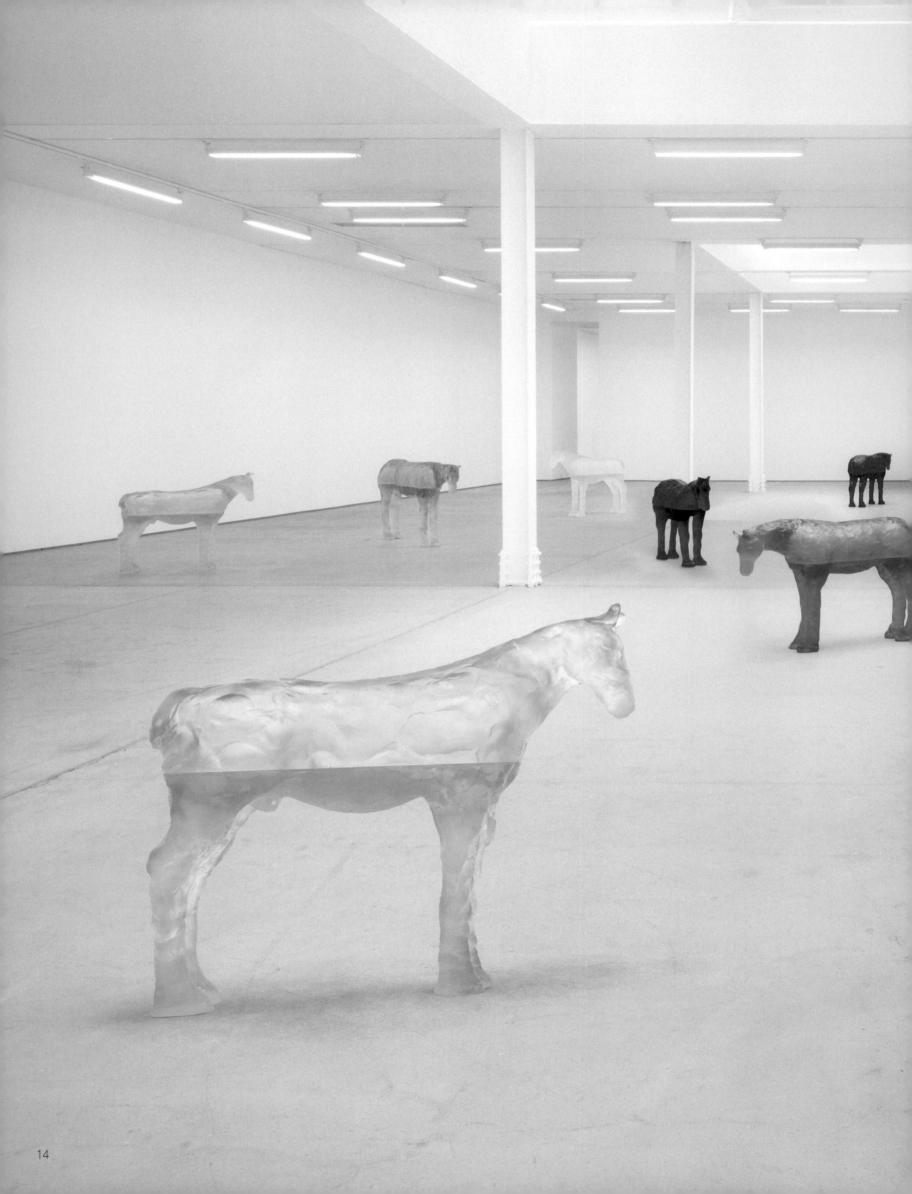

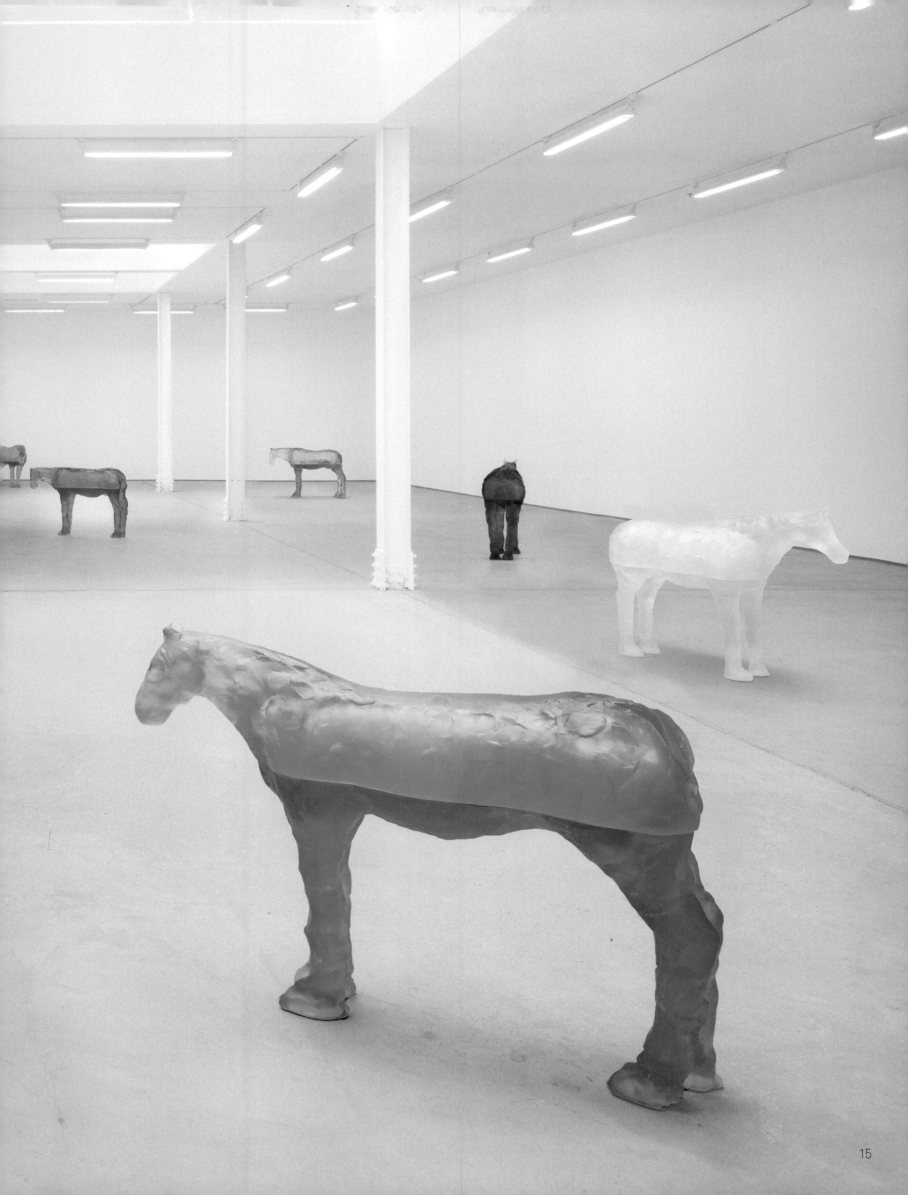

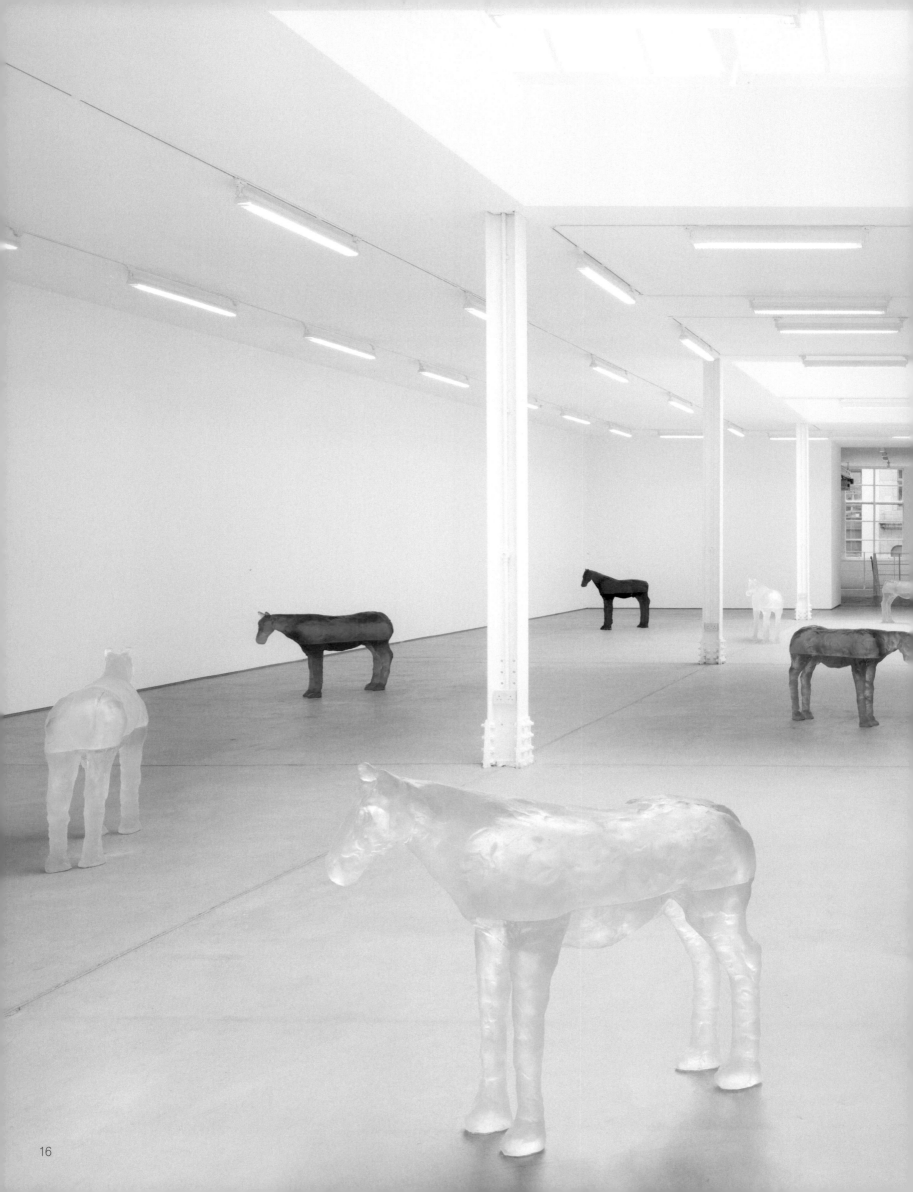

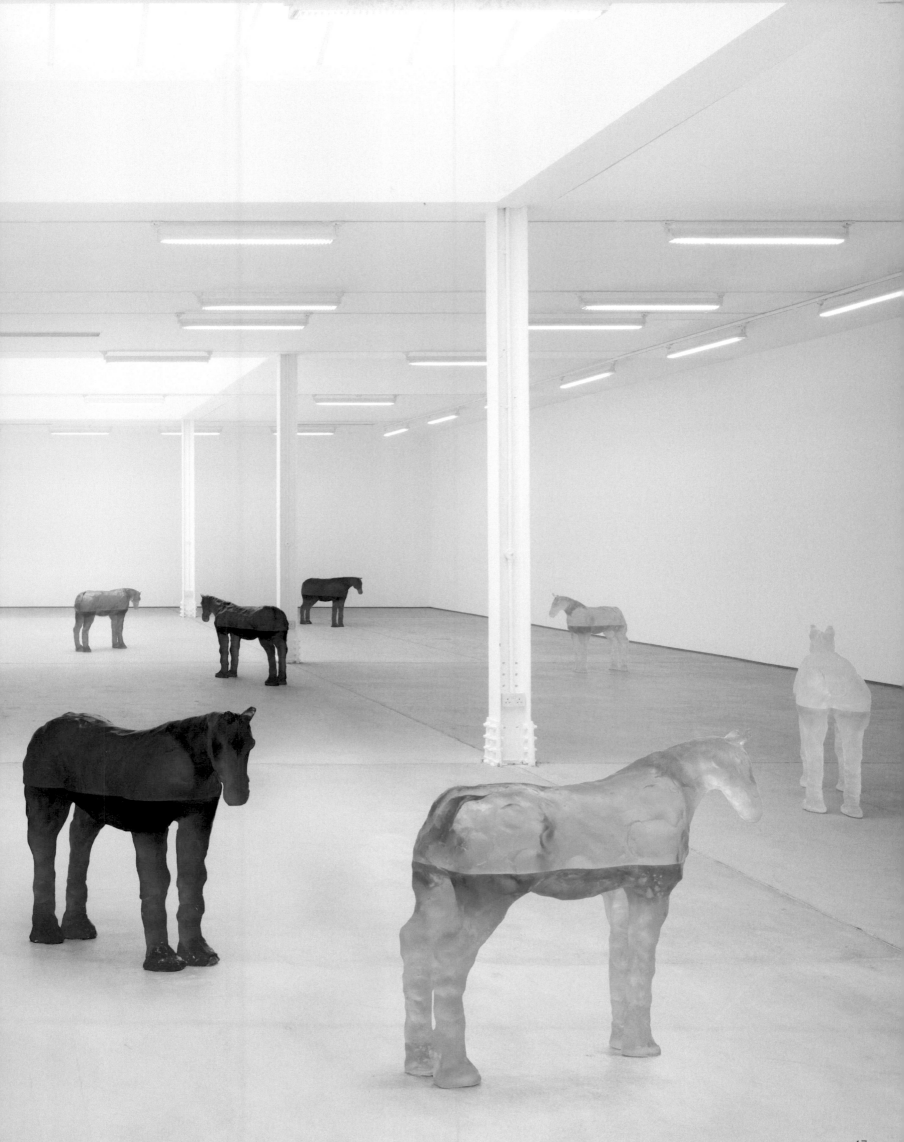

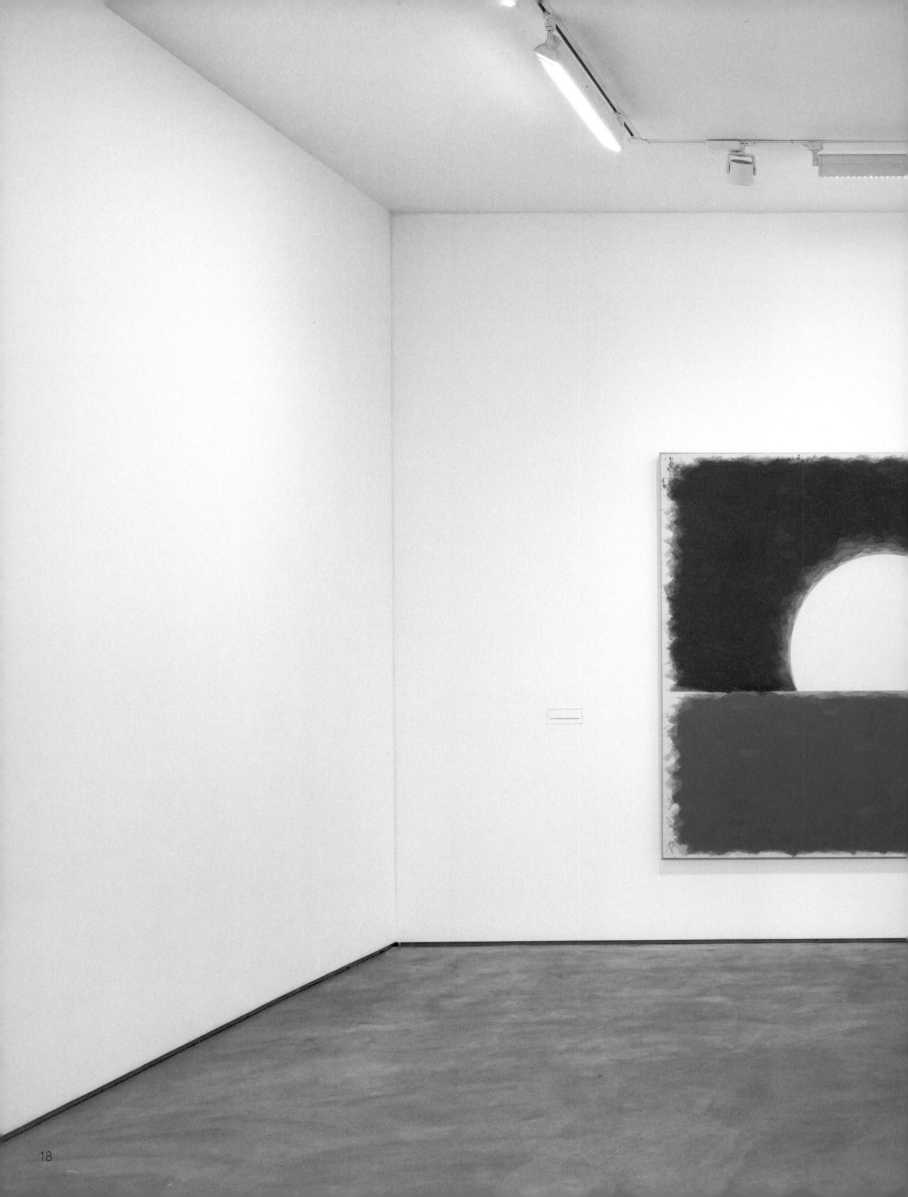

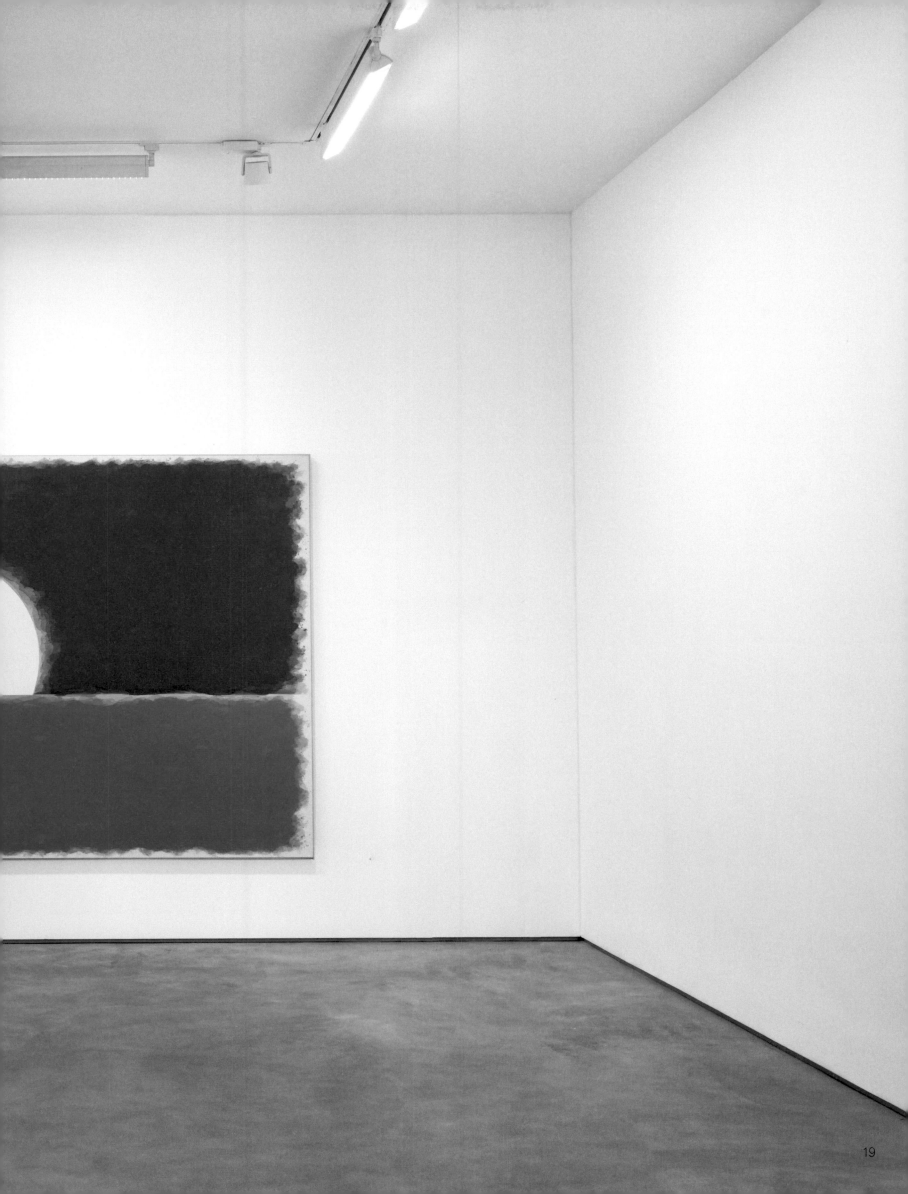

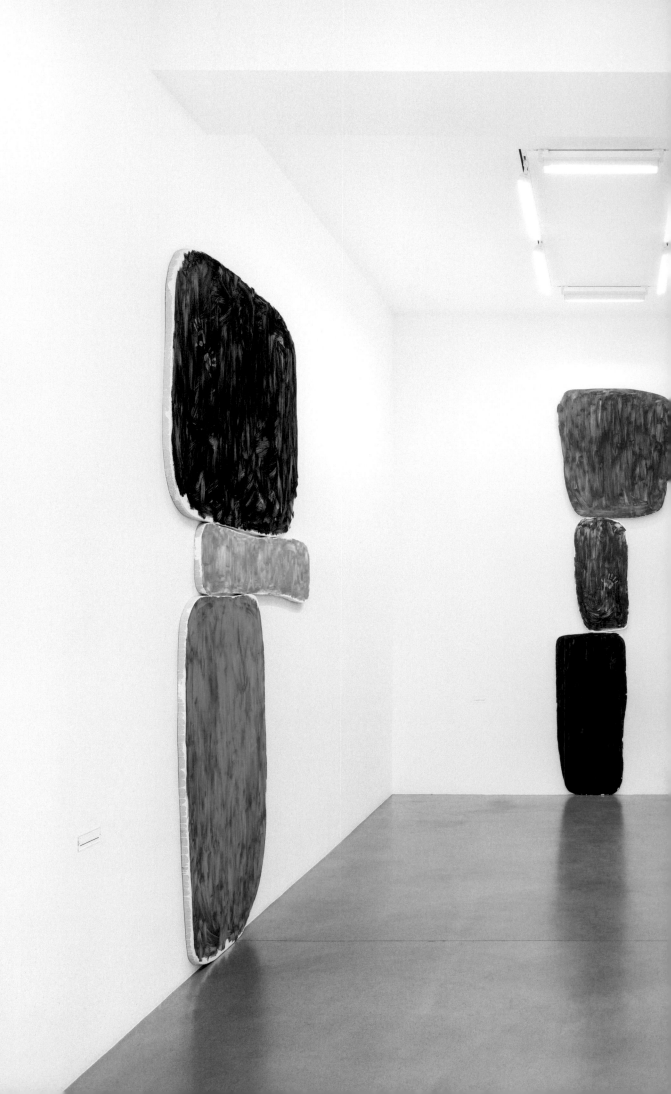

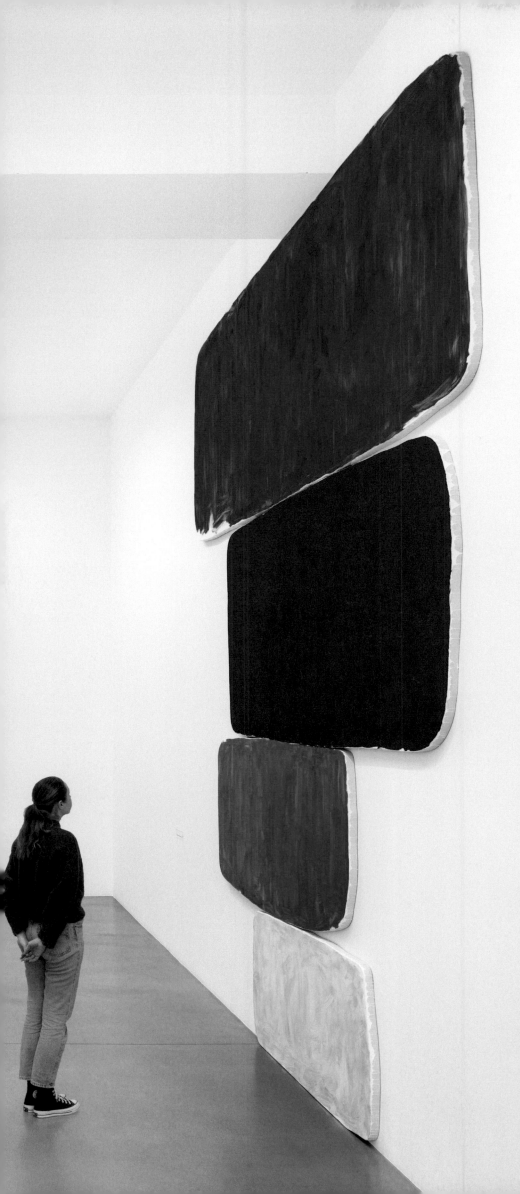

a rainbow . a nude . bright light . summer

kamel mennour june 2 - august 31 2021

A naked woman is sitting on the floor. Her eyes are closed. Her head is bowed. As is her upper body, stabilised by her left arm, while her right arm, slightly further back, rests on her foot. The sculpture is human in appearance and visibly moulded from a model full of bodily vigour – and for good reason: this is a dancer. Yet this sculpture makes no attempt at concealing an artificiality – reinforced by the application of colour on the body – springing from the production process, as attested by the treatment of certain joints and the intentional visibility of strings which, like those of a puppet, exclude any pretensions to hyper-realism.

The woman is situated in a polychrome space open to the street, allowing her surroundings to be flooded with summer light. She blends into her setting, where the more "natural" matrix sculptures had made play with contrast. The work derives from a family of nudes Rondinone created in 2010–2011, using a mix of wax and earth colours. In this group dating back 10 years or so, as in the sculpture on display here, we can detect speculation about tempus fugit that is only exacerbated by the disparity between the vitality of the mature bodies and the fragility of the wax. A beautiful, all but untranslatable German word reflects this separation and transience: Vergänglichkeit.

Equally significant is the polychrome character of this sculpture, echoed in the gallery's walls, ceiling and floor (it should be remembered that for Ugo Rondinone, the exhibition and its presentation approach constitute a "form" in their own right and are in no way reducible to a mere "neutral" envelope). Coming in the wake of a number of polychrome sculptures produced in recent years, this is a perfect example of the transmutation characteristic of the Rondinone method: from family to family, processes of hybridisation, transfer and mutation intermingle and enrich his work with additional intertextual layers. A constantly renewed work in progress of which this nude is a new chapter.

Erik Verhagen

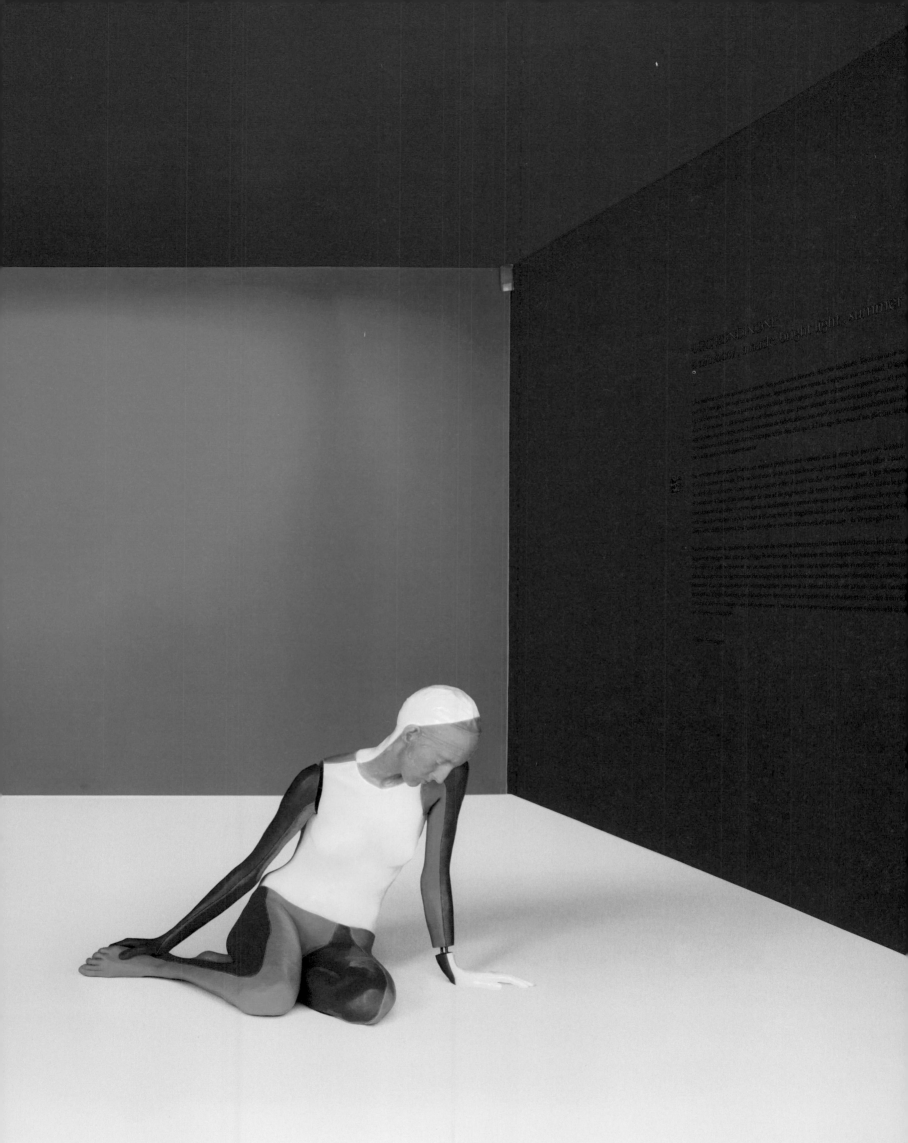

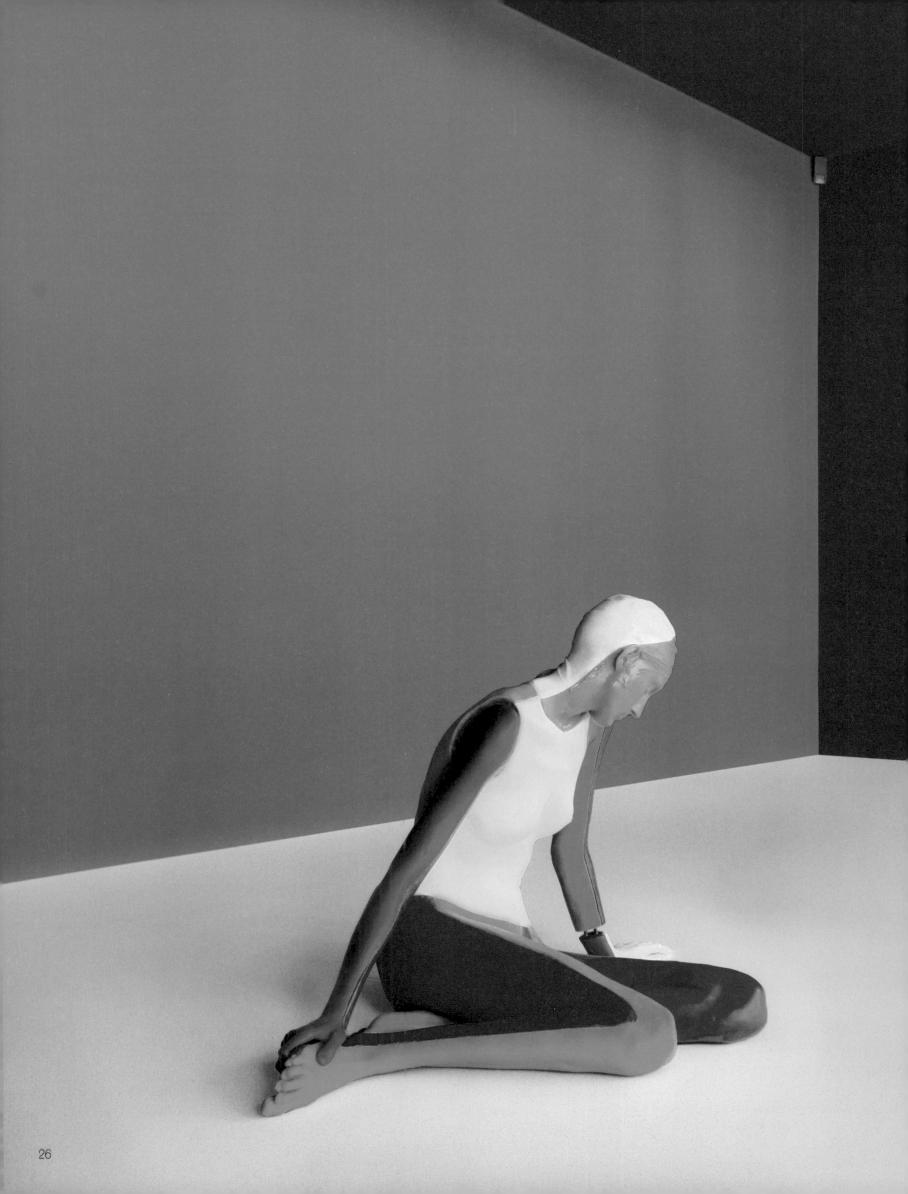

UGO RONDINONE
a rainbow, a nude, a night, light, summer

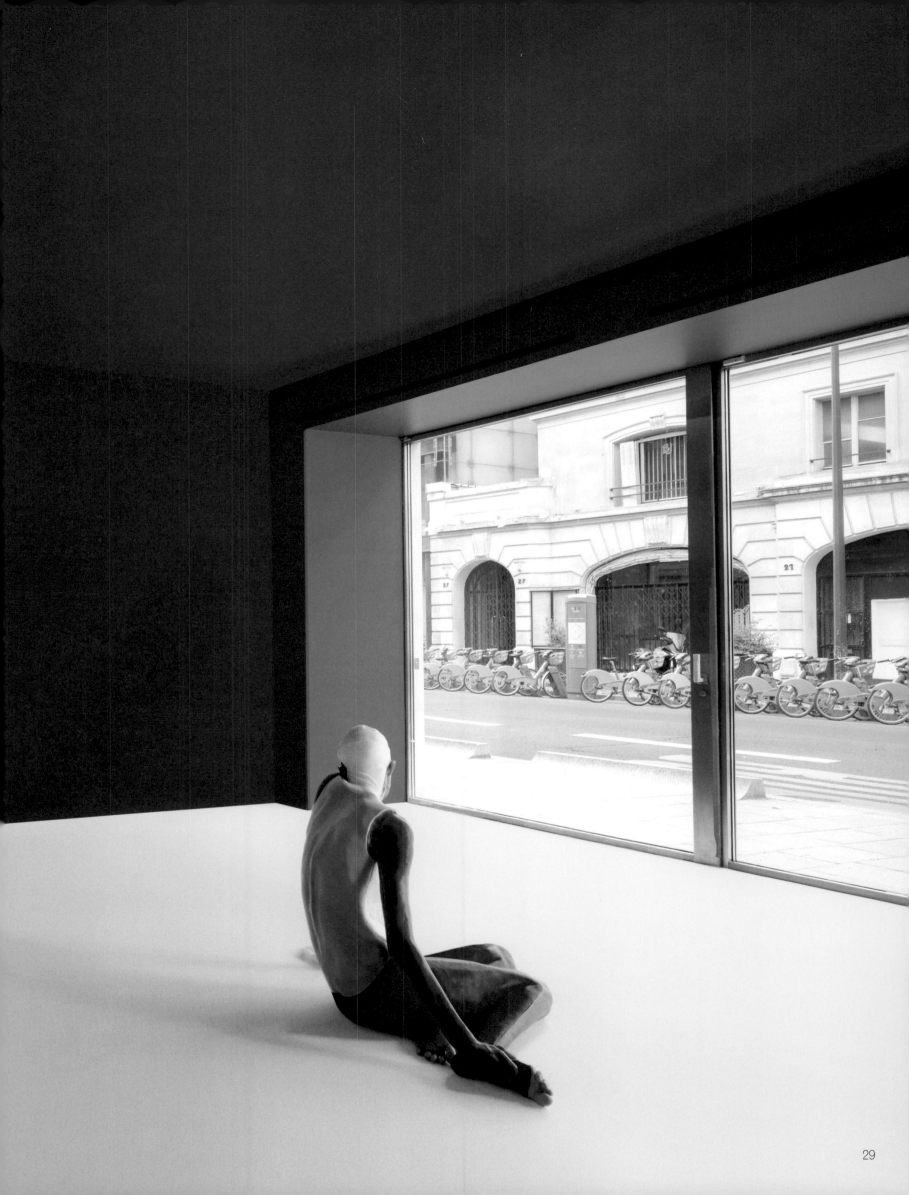

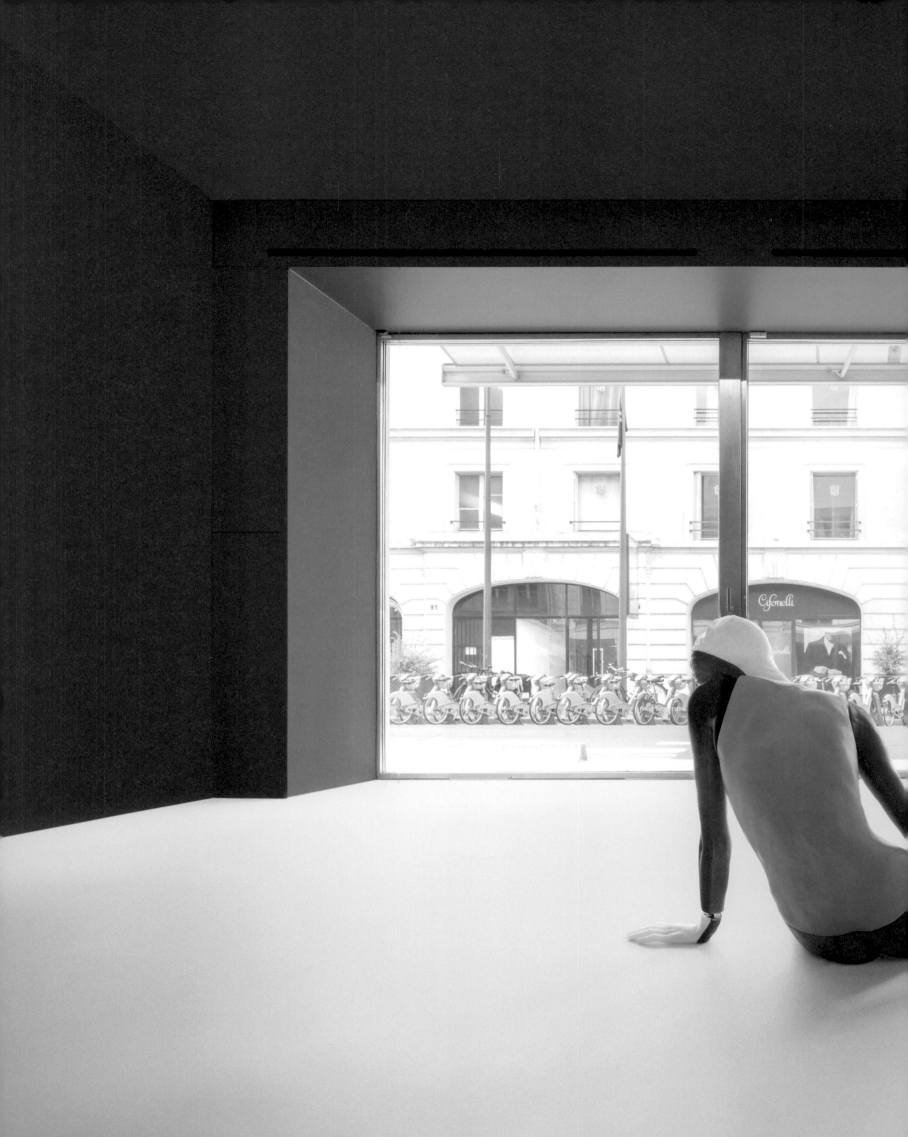

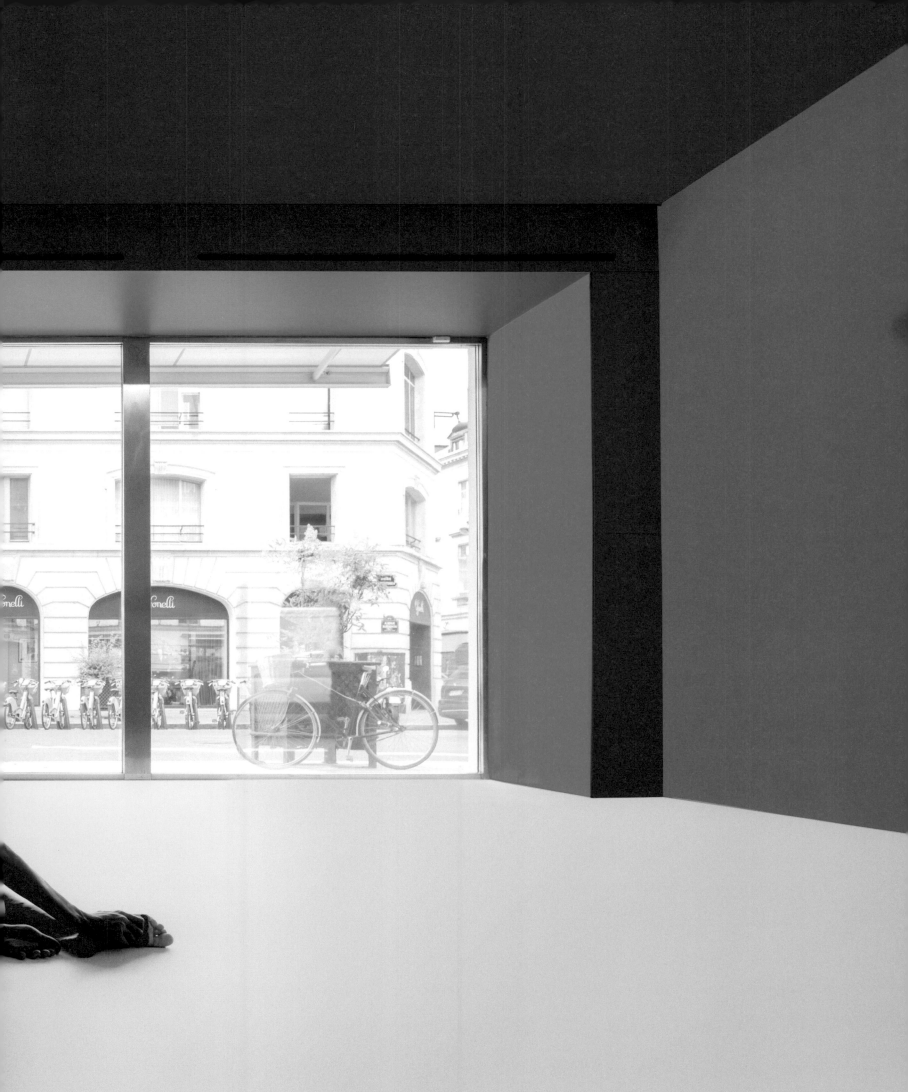

a low sun . golden mountains . fall

galerie krobath november 4 - december 22 2021

Spires, totem poles, spikes, figures, pillars, chimneys, towers, groups of people: The appearance of hoodoos, bizarre rock formations mainly found in the USA, conjure up a lot of allusions. One of the most iconic hoodoos is called "Thor's Hammer" and there are also others with telling names like "Les Orgues" ("The Organs") or "The Hunter". Hoodoos were the inspiration for Ugo Rondinone's *Seven Magic Mountains* (2016), an installation of seven monumental sculptures, which the artist erected in the desert of Nevada, each consisting of various boulders stacked on top of each other and painted in bold colours that are in stark contrast to the surroundings. Their predecessors, those sculptures where Rondinone worked with rock for the first time, are nine human figures that he installed at the Rockefeller Plaza in New York in 2013. While the rocks the artist used for his sculptures in the city were left in their natural state and were just rough-hewn, the boulders for the sculptures in the landscape are in almost surreal and artificial colours.

The exhibition *a low sun . golden mountains . fall* comprises 13 pieces from a group of works which is basically a continuation of Seven Magic Mountains, and two of his "suns". The sculptures are small, each consisting of three stones, just as colourful as the larger versions. The rocks sit on top of one another in an unstable balance that is held together by a construction hidden inside them. Their colours are so intensive that the "mountains" literally stand out against the space around them, as if claiming a space of their own.

In his works, the artist runs through "an alphabet of archetypes", as he puts it – suns, clouds, mountains and moons are recurring elements in his oeuvre. The fact that the "mountains" are reminiscent of cairns is another reference to their archaic character. These formations can still be found in various sizes and shapes on every rocky beach. As amateurish as they might seem, they are the expression of a fundamental creative drive all humans share. However, they are of an ephemeral nature: the next storm or the next wave will destroy them. Even though Rondinone's "mountains" suggest that they might topple any time, their fragility only exists in theory. In the setting of the exhibition at the Krobath Gallery, this fragility has been made almost physically palpable by placing the "mountains" on pedestals of varying heights. No false move or the rocks will fall from

the pedestals! Thus, the "fall" in the title of the exhibition is equivocal, referring to both the season fall and also to the act of falling.

Like the "mountains", Rondinone's "suns", which he has been creating since 1992, are also part of his archaic vocabulary. The blurry effect is a result of him using an airbrush technique and it evokes the same effect one has when looking directly at the sun. In this way, both groups of works refer to specific natural phenomena, which elevates them to a timeless level: Mountains and the sun have already existed much longer than humankind and will most likely survive humans in the remote future. However, the titles summon these works to the here and now, making them concrete: The titles of the "suns" are the dates of their making (*sixthofmaytwothousandtwentyone*, *twentiethofmaytwothousandfourteen*), and the titles of the "mountains" refer to their size and colours, for example *small blue yellow pink mountain*, *small pink white green mountain* or *small orange yellow silver mountain*.

There is also an art historical dimension to these works: The relation of the "mountains" to land art is striking, as is the reference of the "sun paintings" to abstract painting. These connotations, however, turn into their opposite the very next moment: While the classic land art becomes one with the landscape, Rondinone's *Seven Magic Mountains* stand in contrast to the landscape. And while the aim of abstract painting is to be non-representational, the "suns" refer to a specific object as the title suggests. That way, the installation oscillates between present moment and timelessness, the specific and the general, the natural and the artificial, the abstract and the representational. It fulfills an act of balance on various levels – just like the rocks in the "mountains".

Nina Schedlmayer

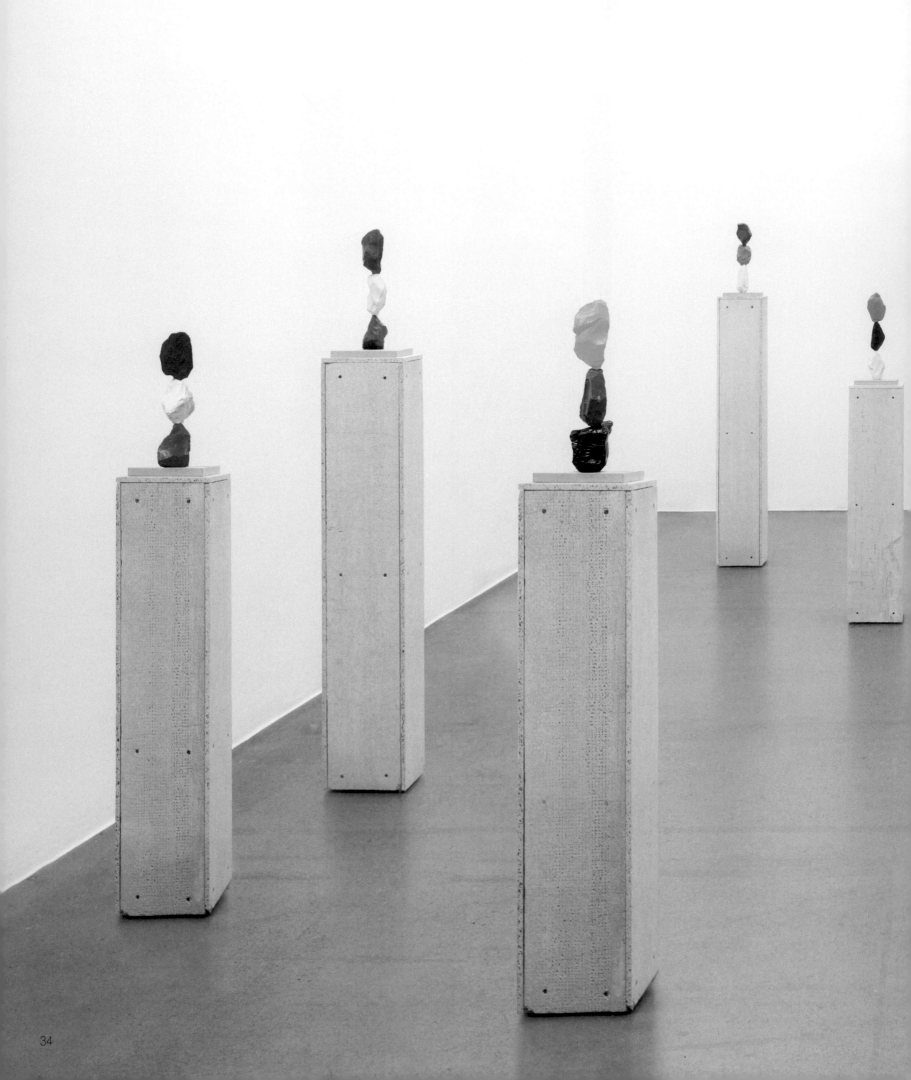

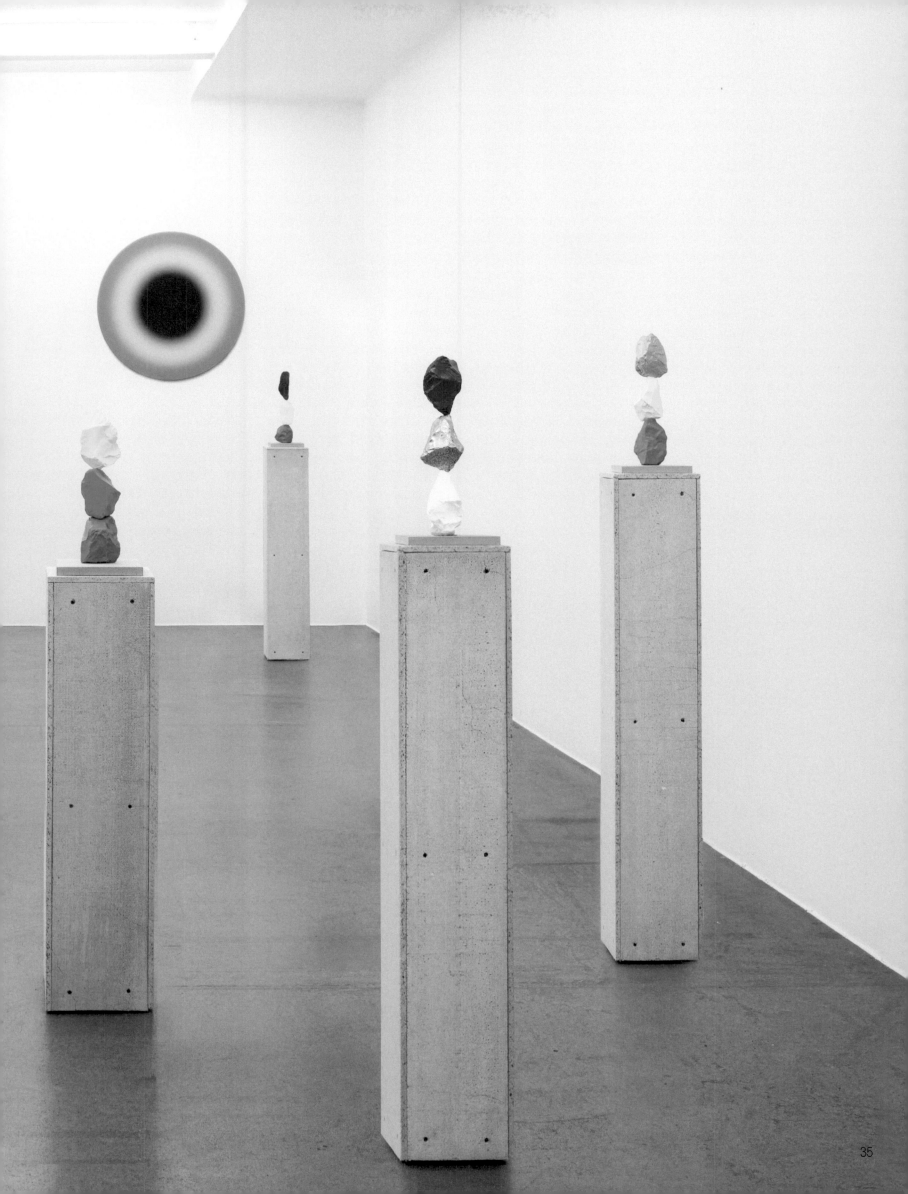

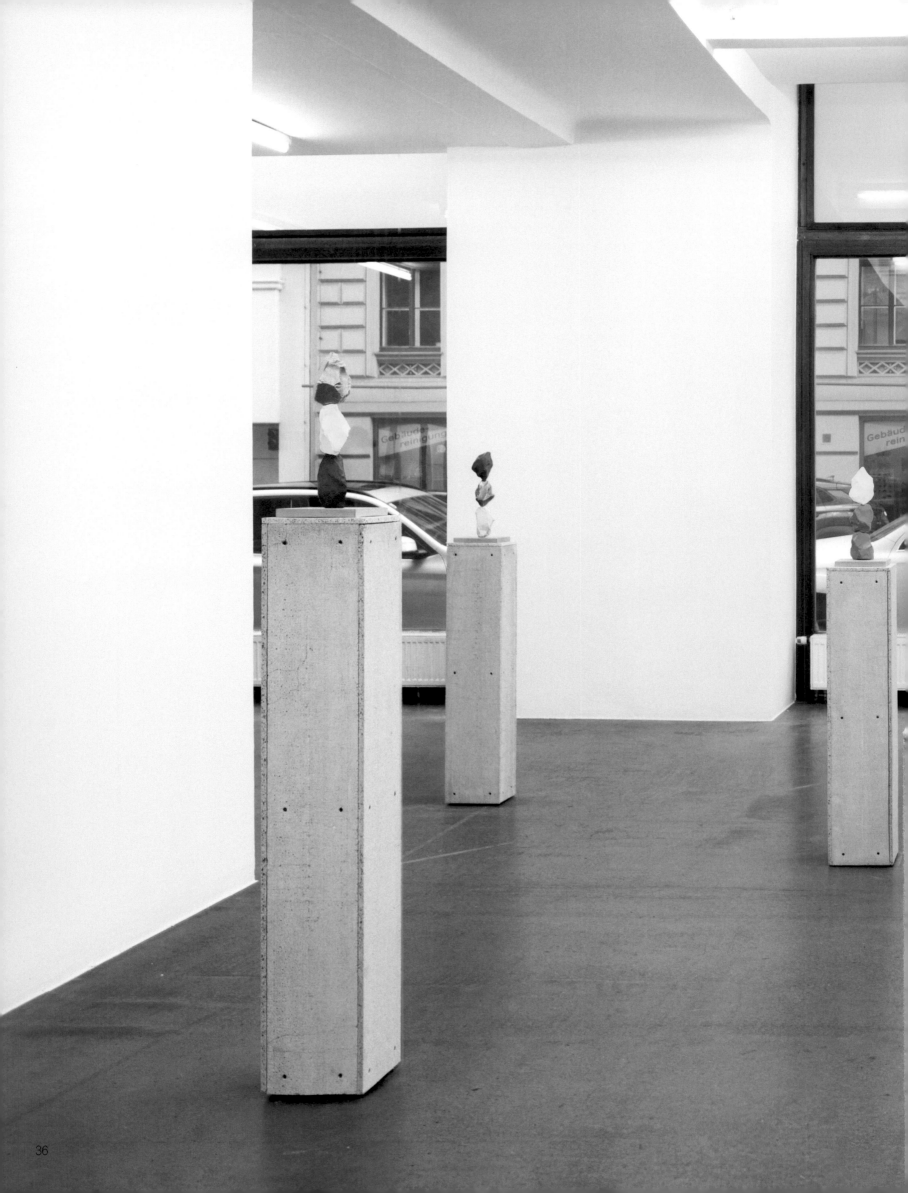

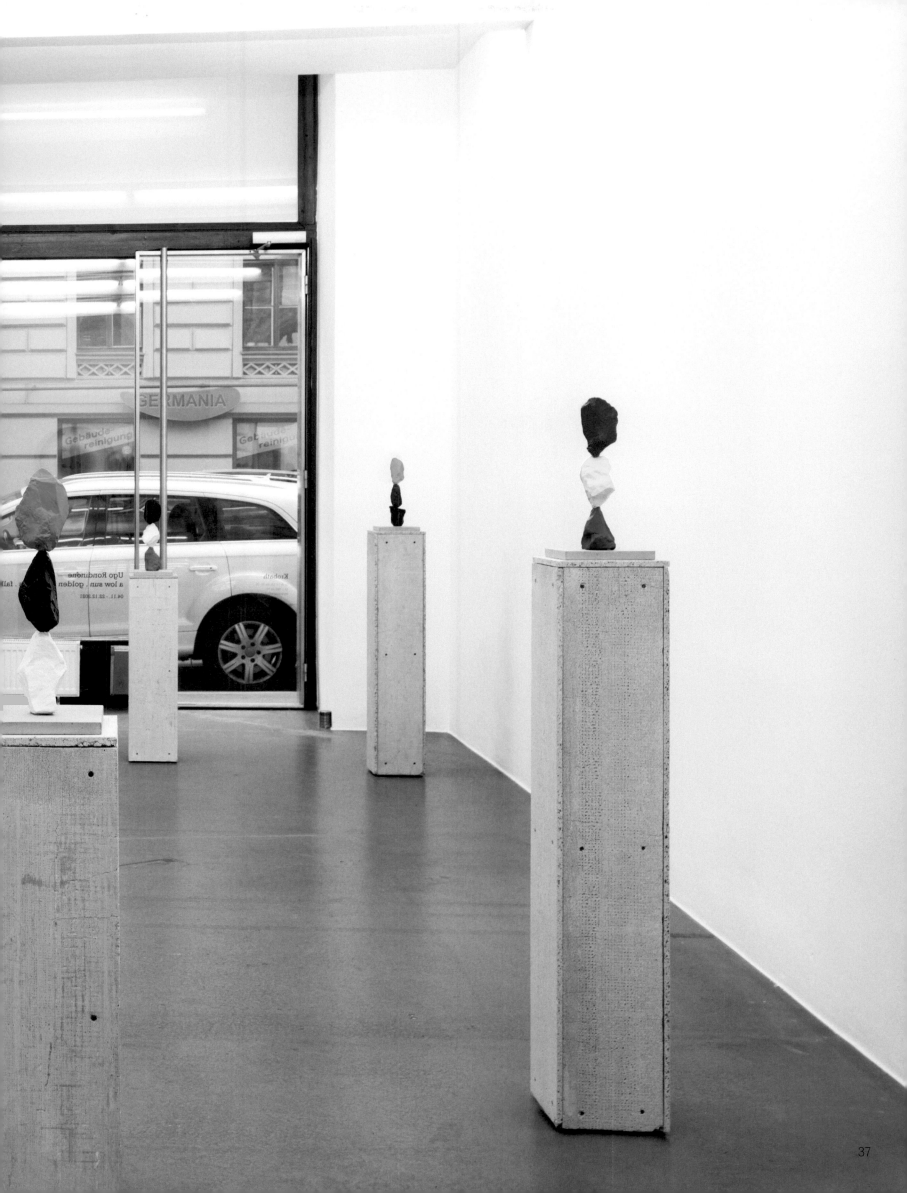

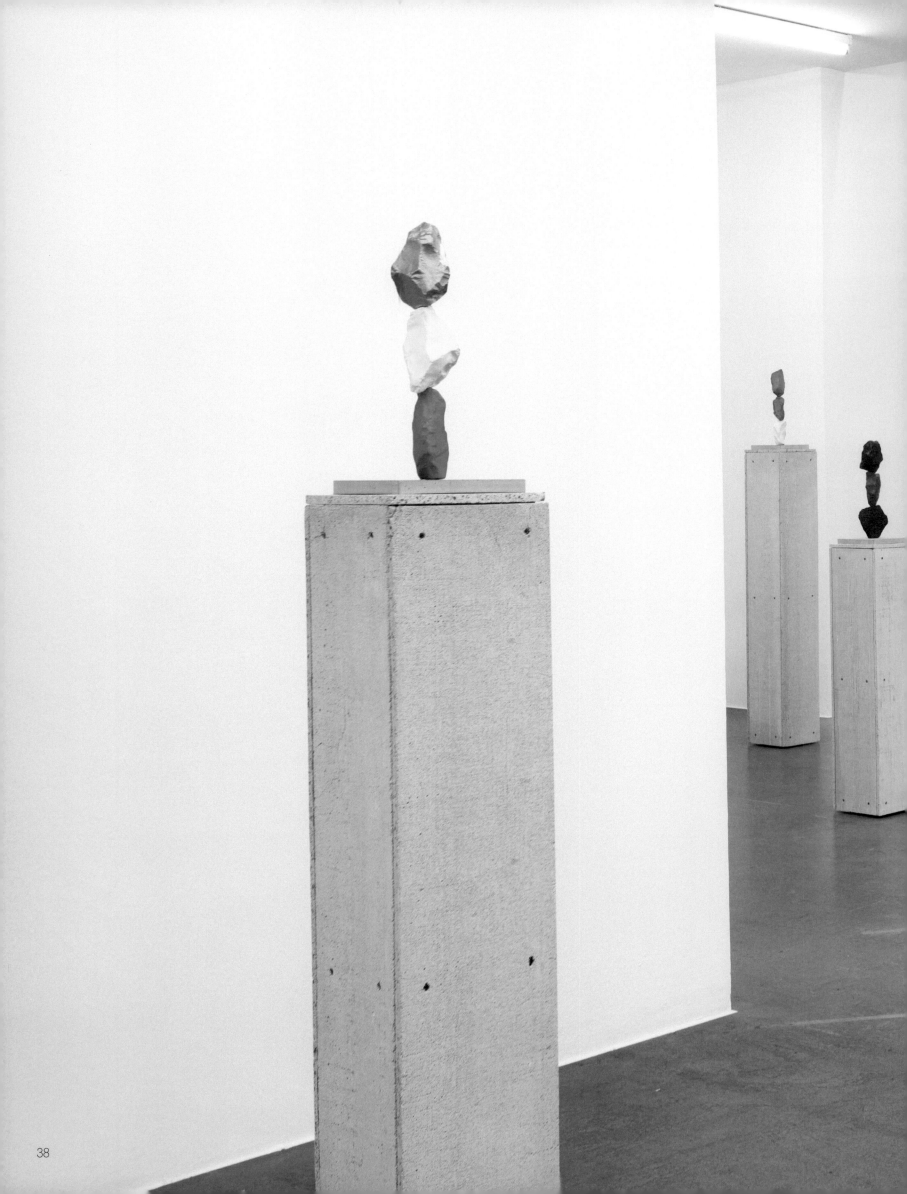

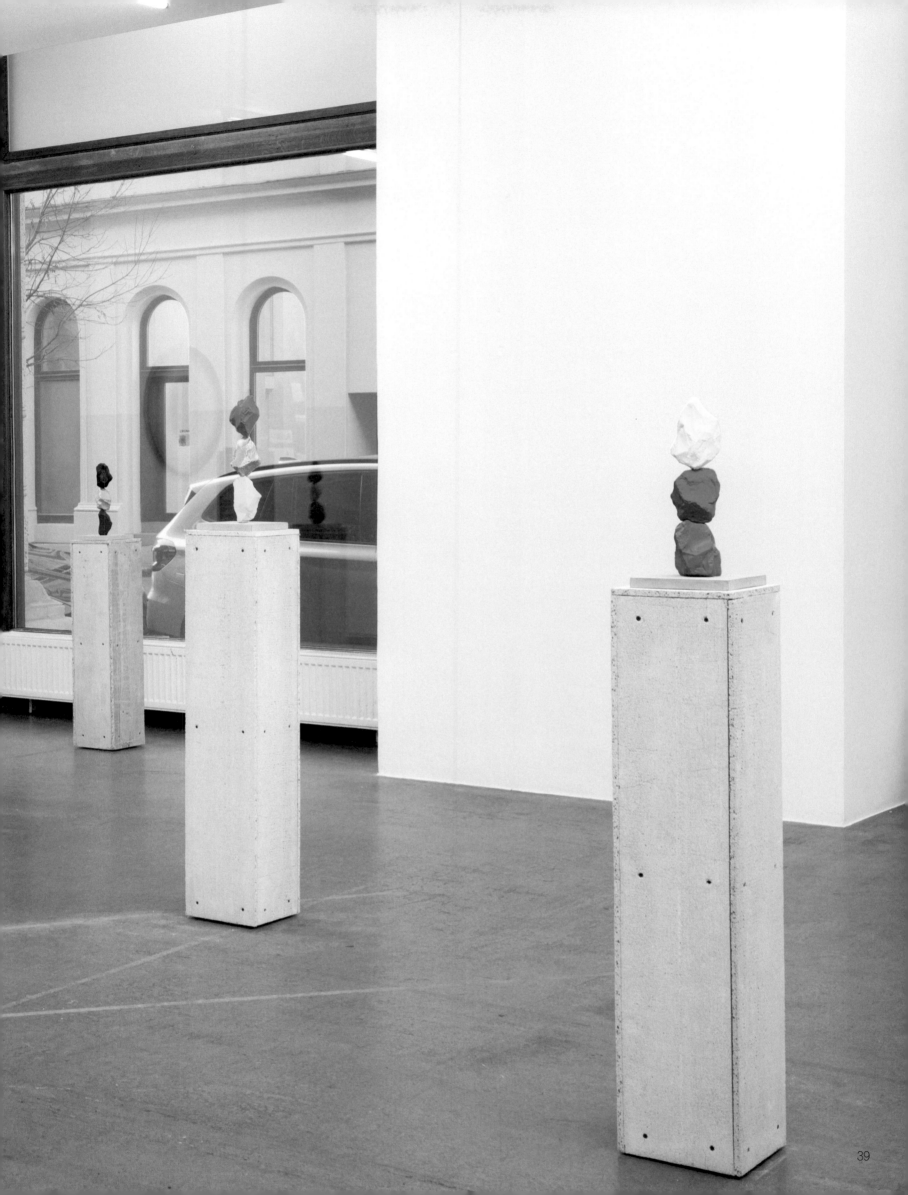

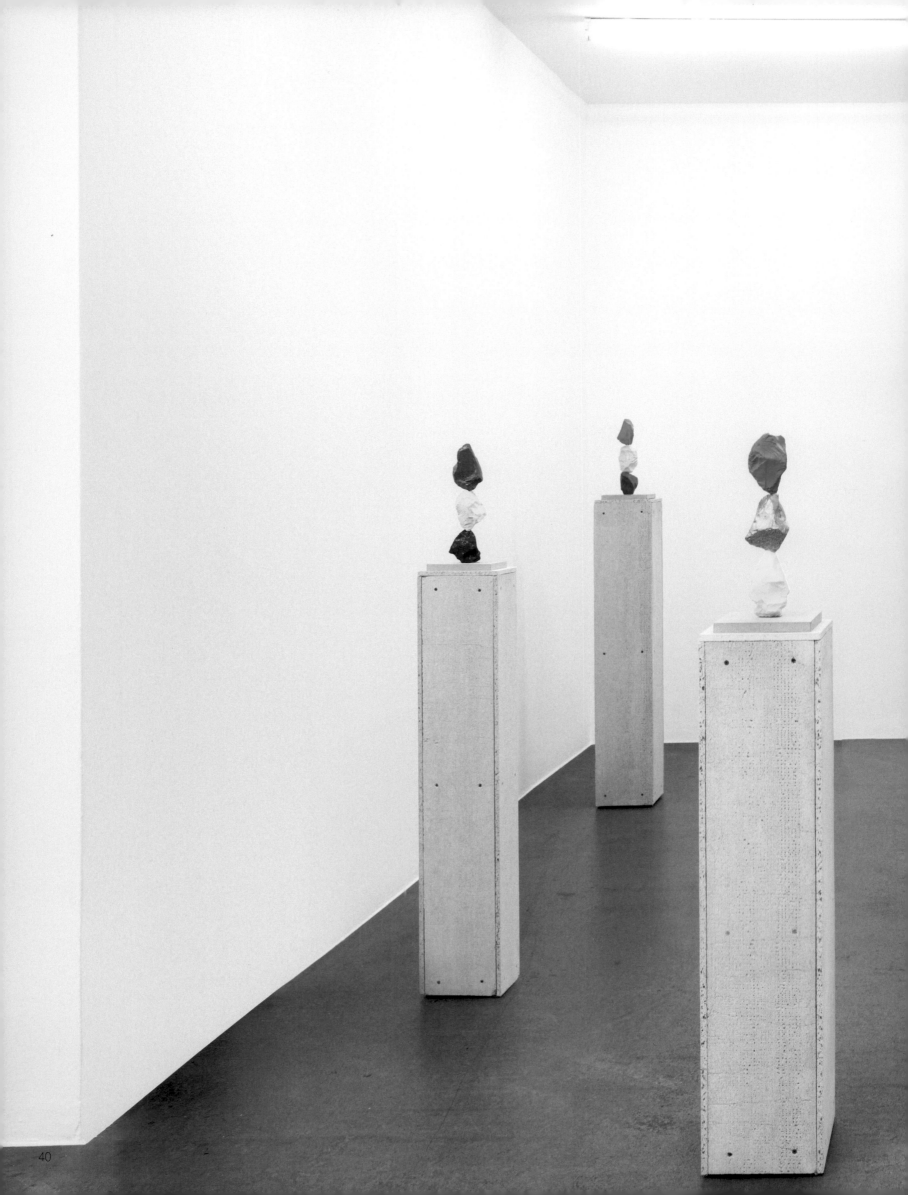

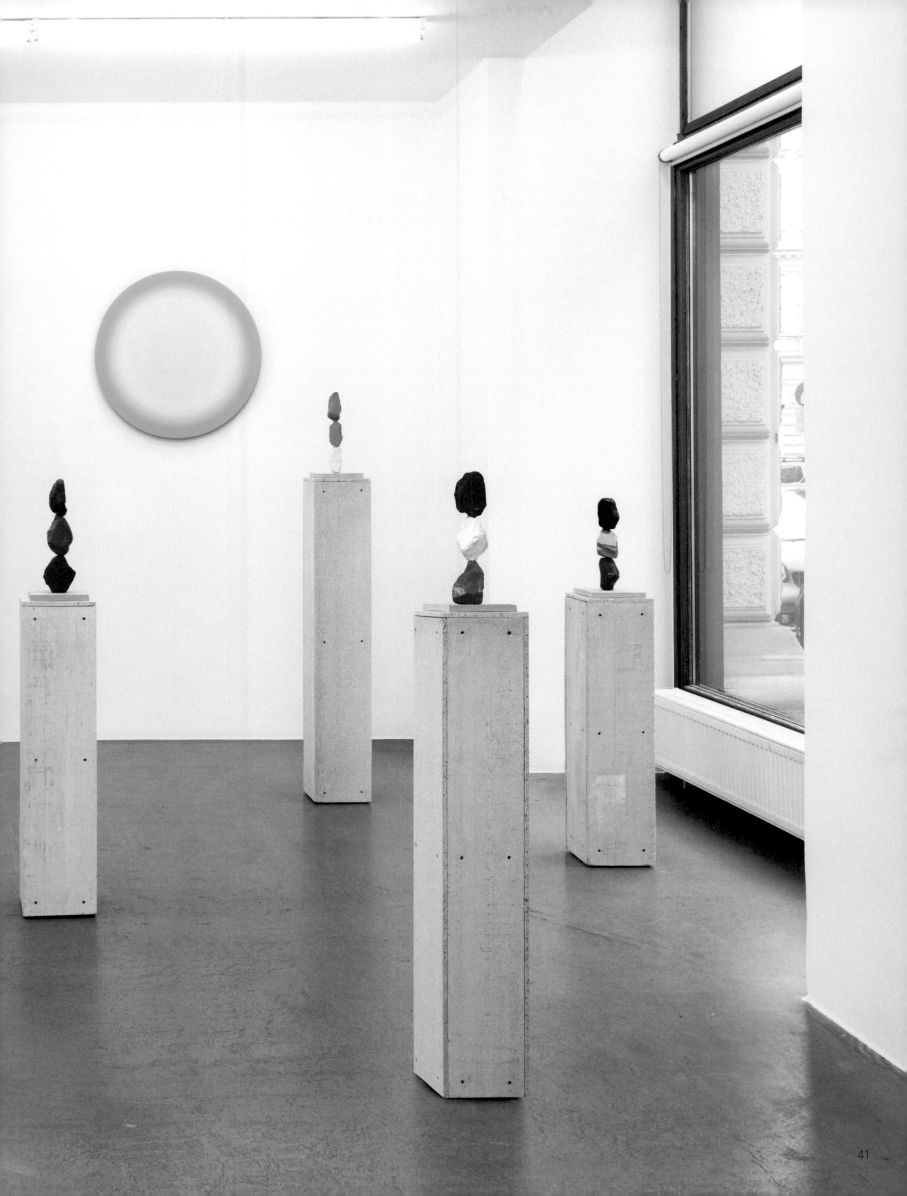

list of works

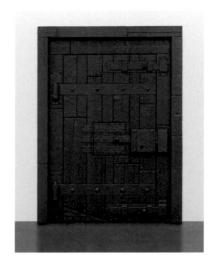

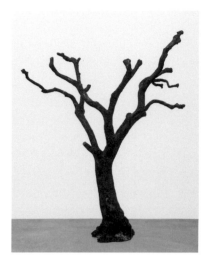

the 15th hour of the poem, 2007
Cast wax, pigments
140 x 82 x 82 cm

all absolute abyss, 2010
wood, fittings, varnish
280 x 217 x 14 cm

the sunflower, 2016
resin, earth, dried sunflowers
283 x 180 x 207 cm

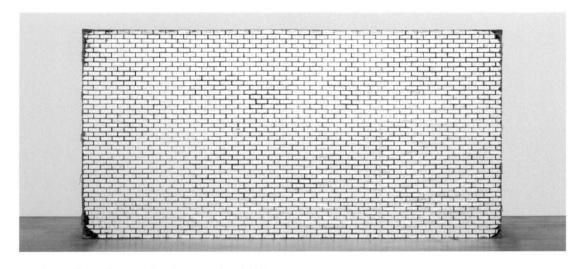

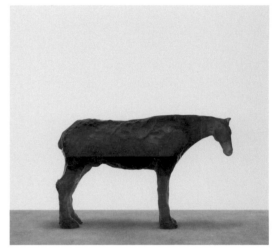

vierteraprilzweitausendundneunzehn, 2019
oil on burlap
300 x 600 cm

caribbean sea, 2021
blue glass
81.3 x 126.9 x 34.6 cm

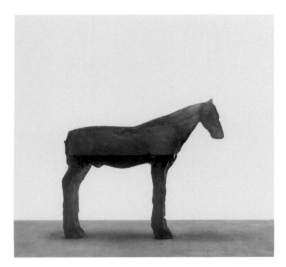

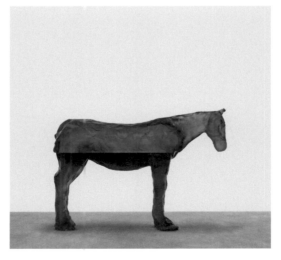

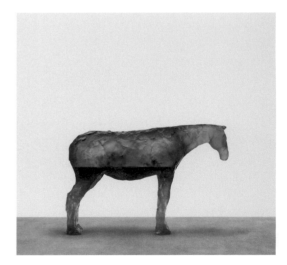

bering sea, 2021
blue glass
100.8 x 119.2 x 28.5 cm

south china sea, 2021
blue glass
86.4 x 124.1 x 32 cm

adriatic sea, 2021
blue glass
83.5 x 125.6 x 36.2 cm

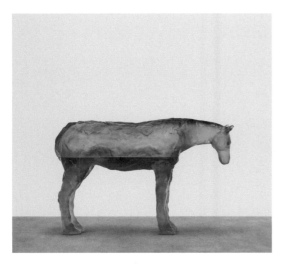

arabian sea, 2021
blue glass
80.2 x 126.5 x 30.4 cm

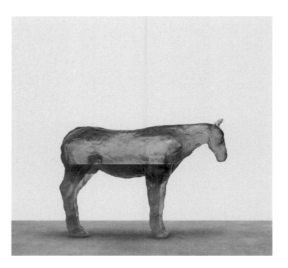

sea of japan, 2021
blue glass
83 x 118.2 x 35 cm

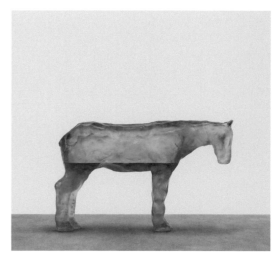

persian gulf sea, 2021
blue glass
77.3 x 128.7 x 30.6 cm

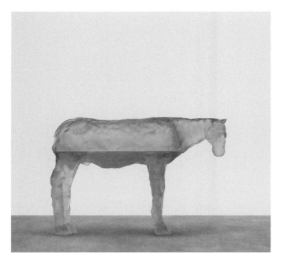

red sea, 2021
blue glass
79 x 119.7 x 30 cm

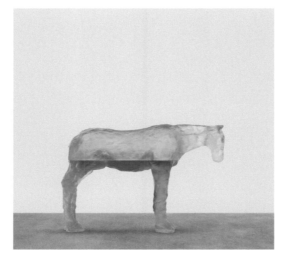

east china sea, 2021
blue glass
82.9 x 125.2 x 30.2 cm

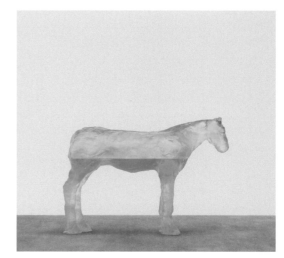

coral sea, 2021
blue glass
86.1 x 122.4 x 31 cm

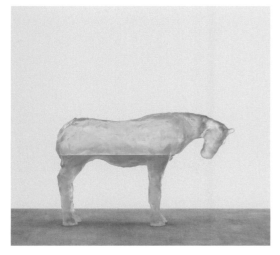

baltic sea, 2021
blue glass
84 x 134 x 43 cm

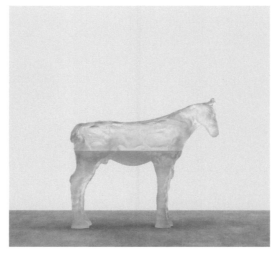

andaman sea, 2021
blue glass
86.7 x 98.6 x 26.7 cm

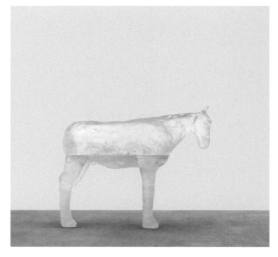

mediterranean sea, 2021
blue glass
89.9 x 120.1 x 32.6 cm

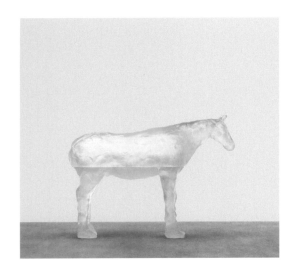

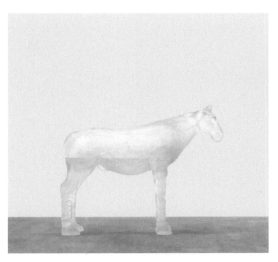

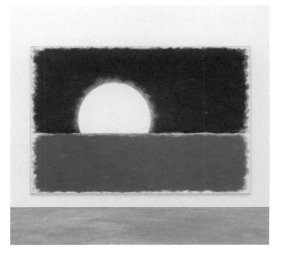

north sea, 2021
blue glass
90.5 x 126.3 x 30 cm

ionian sea, 2021
blue glass
90 x 120.9 x 33.2 cm

achtundzwanzigsterjunizweitausendund-
zwanzig, 2020
watercolor on canvas, artist's frame
200 x 300 cm

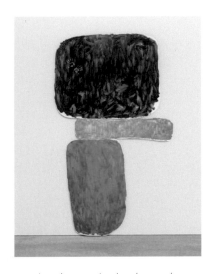

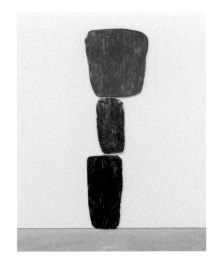

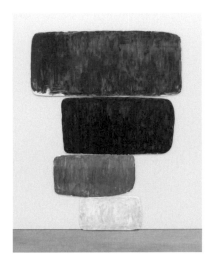

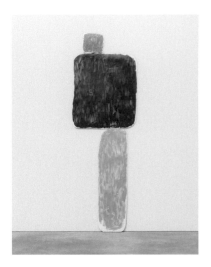

zweiundzwanzigsterdezember-
zweitausendundzwanzig, 2021
oil on canvas
453 x 258 x 5 cm

vierterjanuarzweitausendund-
einundzwanzig, 2021
oil on canvas
478 x 148 x 5 cm

dreiundzwanzigsterjanuarzwei-
tausendundeinundzwanzig, 2021
oil on canvas
528 x 386 x 5 cm

zwölfterfebruarzweitausendund-
einundzwanzig, 2021
oil on canvas
547 x 174 x 5 cm

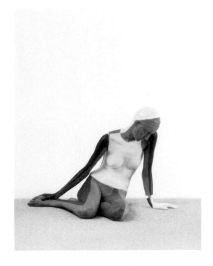

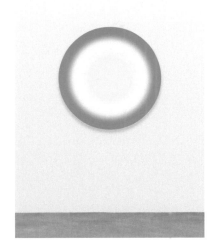

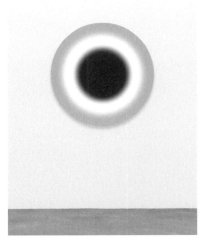

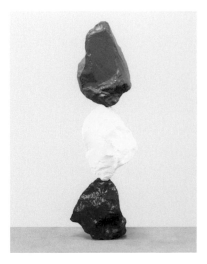

nude (xxxxxxxxxxxx)
(rainbow), 2021
wax mixed with day-
glow pigments
74 x 109 x 64 cm

zwanzigstermaizweitausend-
undvierzehn, 2014
Acrylic on canvas
Ø 80 cm

sechstermaizweitausendundein-
undzwanzig, 2021
acrylic on canvas
Ø 90 cm

small blue yellow pink
mountain, 2021
painted stone, stainless steel
32 x 9 x 7 cm

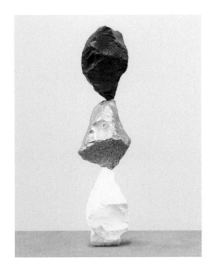

*small yellow silver blue
mountain*, 2021
painted stone, stainless steel
34.5 x 8.5 x 8.5 cm

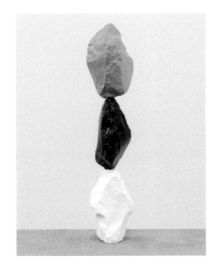

*small white black green
mountain*, 2021
painted stone, stainless steel
36 x 8 x 8.5 cm

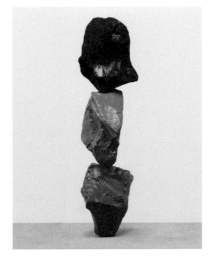

*small red pink violet
mountain*, 2021
painted stone, stainless steel
34.5 x 11 x 10 cm

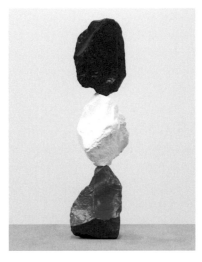

*small blue white red
mountain*, 2021
painted stone, stainless steel
33 x 8 x 9 cm

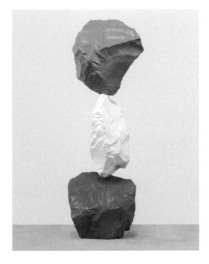

*small pink white green
mountain*, 2021
painted stone, stainless steel
32 x 10 x 9 cm

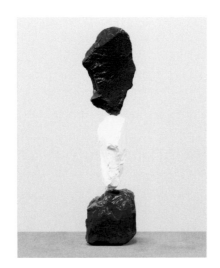

*small blue yellow violet
mountain*, 2021
painted stone, stainless steel
39.5 x 9 x 9.5 cm

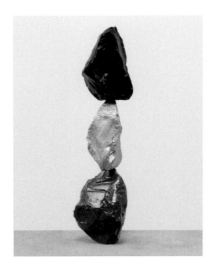

*small violet silver black
mountain*, 2021
painted stone, stainless steel
31.5 x 9 x 7 cm

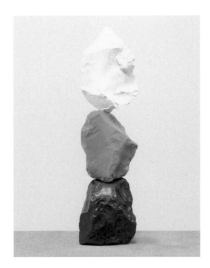

*small blue green yellow
mountain*, 2021
painted stone, stainless steel
32.5 x 9.5 x 7 cm

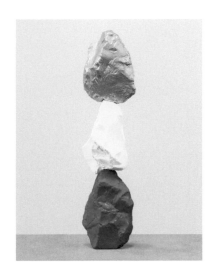

*small orange yellow
silver mountain*, 2021
painted stone, stainless steel
34.5 x 9.5 x 7.5 cm

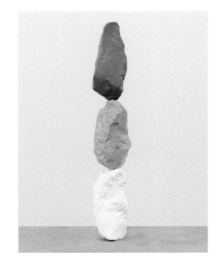

*small yellow green orange
mountain*, 2021
painted stone, stainless steel
32.5 x 6 x 5.5 cm

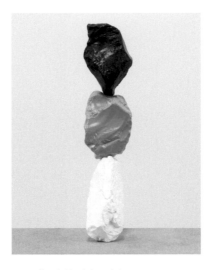

*small white blue blue
mountain*, 2021
painted stone, stainless steel
34 x 7.5 x 8 cm

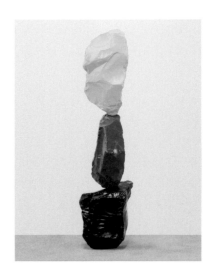

*small black green green
mountain*, 2021
painted stone, stainless steel
31 x 9 x 6 cm

biography

ugo rondinone

1964
born in brunnen, switzerland

1986–90
studied at the hochschule für angewandte kunst, vienna

lives and works in new york

solo exhibitions

2022
life time, schirn kunsthalle frankfurt, frankfurt
vocabulary of solitude, museo tamayo, mexico city
chuck nanney + joel otterson, curated by ugo rondinone, galerie
eva presenhuber, zurich
burn shine fly, scuola grande san giovanni evangelista di venezia,
venice
nuns and monks by the sea, kukje gallery, seoul and busan

2021
nude in the landscape, belvedere 21, vienna
vocabulary of solitude, auckland art gallery, new zealand
a low sun . golden mountains . fall, galerie krobath, vienna
sail me on a silver sun, the national exemplar, iowa city
still. life, tennis elbow, the journal gallery, new york
waterfalls and clouds, two person exhibition with pat steir, galerie
eva presenhuber, zürich
ned smyth - life, curated by ugo rondinone, landcraft garden,
mattituck
your age, my age, and the age of the rainbow, belvedere 21, vienna,
austria
a rainbow . a nude . bright light . summer, kamel mennour, paris
chuck nanney + joel otterson, curated by ugo rondinone, martos
gallery, new york
a yellow a brown and a blue candle, the national exemplar, iowa city
nuns + monks, gladstone gallery, new york
a sky . a sea . distant mountains . horses . spring, sadie coles hq,
london
feeling the void and the rhone, kunsthalle marcel duchamp, cully
a wall. a door. a tree. a lightbulb. winter, skmu sørlandets
kunstmuseum, kristiansand

2020
the monk, gladstone gallery, rome
nuns + monks, galerie eva presenhuber, zürich

nuns + monks, esther schipper, berlin
poetry, the national exemplar, iowa city

2019
medellín mountain, medellín modern art museum, colombia
thanx 4 nothing, gladstone gallery, new york
*a wall . seven windows . four people . three trees . some clouds . one
sun*, kamel mennour, paris
everyone gets lighter, kunsthalle helsinki, finland
sunny days, guild hall, east hampton
thanx 4 nothing, carré d'art, chapelle des jésuites, nîmes
earthing, kukje gallery, seoul

2018
the true, laguna gloria, the contemporary austin
liverpool mountain, liverpool biennial, tate liverpool
clockwork for oracles, phillips, paris
the marciano collection, marciano foundation, los angeles
the radiant, malta international contemporary art space, valetta
drifting clouds, gladstone gallery, new york
your age and my age and the age of the sun, fundación casawabi,
puerto escondido

2017
vocabulary of solitude, arken museum of modern art, ishøj
moonrise. east. july, aspen art museum, aspen
good evening beautiful blue, bass museum of art, miami
flower moon, bristol hotel, paris
where do we go from here, the istanbul biennial, istanbul
i love john giorno, various institutions, new york,
the sky over manhattan, sky art, newyork,
the world just makes me laugh, berkeley art museum and pacific
film archive, berkeley
let's start this day again, contemporary arts center, cincinnati
winter moon, maxxi, rome,
your age my age and the age of the rainbow, the garage museum of
contemporary art, moscow

2016
every time the sun comes up, placevendome, paris
two men contemplating the moon 1830, esther schipper, berlin
miami mountain, bass museum of art, miami
the sun at 4pm, gladstone gallery, new york
girono d'oro + notti d'argento, mercati dietraiano, rome
girono d'oro + notti d'argento, macro, rome
becoming soil, carre d'art, nîmes
seven magic mountains, art production fund and nevada museum
of art / desert of nevada
vocabulary of solitude, boijmans van beuningen, rotterdam
primordial, gladstone gallery, brussels
ugo rondinone: moonrise sculptures, the institute of contemporary
art (ica), boston
windows, poems, and stars, la caja negra, madrid

2015
i love john giorno, palais de tokyo, paris

mountains + clouds + waterfalls, sadie coles hq, london
feelings, kukje gallery, seoul
walls + windows + doors, galerie eva presenhuber, zurich
golden days and silver nights, art gallery of nsw, sydney
artists and poets, curated by ugo rondinone, secession, vienna
clouds, galerie krobath, vienna

2014
breathe walk die, rockbund art museum, shanghai
naturaleza humana, museo anahuacalli, coyoacán

2013
human nature, public art fund, rockefeller plaza, new york
*we run through a desert on burning feet, all of us are glowing our
faces look twisted*, art institute of chicago, chicago
thank you silence, m museum, leuven
pure moonlight, almine rech gallery, paris
primal, esther schipper, berlin
soul, gladstone gallery, new york
soul, galerie eva presenhuber, zurich
primal, sommer contemporary art, tel aviv
poems, sorry we're closed, brussels
fatima center for contemporary culture, monterrey

2012
primitive, the common guild, glasgow
pure sunshine, sadie coles hq, london
nude, cycladic art museum, athens
wisdom?peace?blank?all of this?, kunsthistorisches museum,
theseustempel, vienna
the moth poem and the holy forest, galerie krobath, vienna

2011
we are poems, gladstone gallery, brussels
new horizon, almine rech gallery, brussels
we are poems, lvmh, palais an der oper, munich
kiss now kill later, galerie eva presenhuber, zurich
*we run through a desert on burning feet, all of us are glowing our
faces look twisted*, art basel, art parcours, basel
outside my window, peder lund, oslo

2010
nude, gladstone gallery, new york
ibm building, new york
turn back time. let's start this day again, fiac, hors les murs, jardins
des tuileries, paris
clockwork for oracles, art basel, art unlimited, basel
sunrise. east, museum dhondt-dhaenens, deurle, belgium
die nacht aus blei, aargauer kunsthaus, aarau

2009
sunrise. east, festival d'automne à paris,
jardin des tuileries, paris
how does it feel?, festival d'automne à paris, le 104, paris
nude, sadie coles hq, london
la vie silencieuse, galerie almine rech, paris

the night of lead, musac, museo de arte contemporáneo
de castilla, léon

2008
clockwork for oracles ii, ica boston, art wall project, boston
turn back time. let's start this day again, galleria raucci/santamaria,
naples
sunrise. east, frieze art fair, outdoor project, london
we burn, we shiver (with martin boyce),
sculpture center, new york
moonrise. east, public art project, art basel, basel
twelve sunsets, twenty nine dawns, all in one,
galerie eva presenhuber, zurich
dog days are over, hayward gallery, southbank centre, london

2007
big mind sky, matthew marks gallery, new york
wohnsiedlung werdweis, kunst und bau, zurich-altstetten
get up girl a sun is running the world (with urs fischer),
church san stae, 52nd venice biennale, venice
our magic hour, arario gallery, cheonan, south korea
air gets into everything even nothing, creative time,
ritz carlton plaza, battery park, new york

2006
giorni felici, galleria civica di modena, modena
on butterfly wings, galerie almine rech, paris
thank you silence, matthew marks gallery, new york
unday, galerie esther schipper, berlin
a waterlike still, ausstellungshalle zeitgenössische kunst, munster
my endless numbered days, sadie coles hq, london
zero built a nest in my navel, whitechapel gallery, london

2005
clockwork for oracles, isr-centro culturale svizzero di milano, milan
sunsetsunrise, sommer contemporary art, tel aviv

2004
sail me on a silver sun, galleria raucci/santamaria, naples
long gone sole, matthew marks gallery, new york
long night short years, le consortium, dijon
clockwork for oracles, australian centre for contemporary art,
melbourne

2003
la criée, théâtre national de bretagne, galerie art & essai, rennes
moonrise, galerie hauser & wirth & presenhuber, zurich
our magic hour, museum of contemporary art, sydney
lessness, galerie almine rech, paris
roundelay, musée national d'art moderne, centre
georges pompidou, paris

2002
in alto arte sui ponteggi, centro culturale svizzero, milan
our magic hour, centre for contemporary visual arts, brighton
coming up for air, württembergischer kunstverein, stuttgart

1988, works on paper inc., los angeles
lowland lullaby (with urs fischer), swiss institute, new york
cigarettesandwich, sadie coles hq, london
the dancer and the dance, galerie krobath wimmer, vienna
no how on, kunsthalle wien, vienna
a horse with no name, matthew marks gallery, new york
on perspective, galleri faurschou, copenhagen

2001
slow graffiti, galerie schipper & krome, berlin
frac paca, marseille
yesterday's dancer, sommer contemporary art, tel aviv
dreams and dramas, herzliya museum of contemporary art, herzliya
kiss tomorrow goodbye, palazzo delle esposizioni, rome
if there were anywhere but desert, galerie almine rech, paris

2000
so much water so close to home, moma p.s.1, new york
love invents us, matthew marks gallery, new york
if there were anywhere but desert, mont-blanc boutique, new york
a doubleday and a pastime, galleria raucci/santamaria, naples
in the sweet years remaining, aarhus art museum, aarhus
hell, yes!, sadie coles hq, london

1999
guided by voices, galerie für zeitgenössische kunst leipzig, leipzig
guided by voices, kunsthaus glarus, glarus
moonlighting, galerie hauser & wirth & presenhuber, zurich
light of fallen stars, yves saint-laurent, new york
in the sweet years remaining, schipper & krome, berlin

1998
in the sweet years remaining, galerie joão graça, lisbon
the evening passes like any other, galerie almine rech, paris
so much water so close to home, galerie krobath wimmer, vienna

1997
stillsmoking, galleria raucci/santamaria, naples
moonlight and aspirin, galleria bonomo, rome
tender places come from nothing, cato jans der raum, hamburg
where do we go from here, le consortium, dijon
1996
dog days are over, migros museum für gegenwartskunst, zurich
le case d'arte, milan
heyday, centre d'art contemporain, geneva

1995
meantime, galerie froment-putman, paris
migrateurs, arc – musée d'art moderne de la ville de paris, paris
cry me a river, galerie walcheturm, zurich

1994
galerie daniel buchholz, cologne
galerie six friedrich, munich

1993
drawings, centre d'art contemporain de martigny, martigny
lightyears, galerie ballgasse, vienna

1992
c, galerie walcheturm, zurich

1991
far away trains passing by, galerie martina detterer, frankfurt
two stones in my pocket, galerie pinx, vienna
i'm a tree, galerie walcheturm, zurich

1989
galerie pinx, vienna

1987
raum für aktuelle schweizer kunst, lucerne

1986
sec 52, ricco bilger, zurich

1985
galerie marlene frei, zurich

publication

design
ugo rondinone
francisco ramirez barrera

texts
marlo saalmink
james cahill
erik verhagen
nina schedlmayer

translation
laurie hurvitz

photography
skmu
eva herzog
julie joubert
rudolf strobl
stefan altenburger

production
dcv

typeface
grotesque mt

paper
gardapat bianka

print
dza druckerei zu altenburg, altenburg

© 2022, ugo rondinone, the authors, photographers, sadie coles
hq, kamel mennour, galerie krobath and dr. cantz'sche verlags-
gesellschaft mbh & co. kg, berlin.

distribution and marketing
dcv
sales@dcv-books.com

isbn 978-3-96912-088-0
printed in germany

published by
dcv
www.dcv-books.com

DCV

imprint

this catalogue was published on the occasion of the exhibitions:

a wall . a door . a tree . a lightbulb . winter
sørlandets kunstmuseum, kristiansand
january 15 – april 11, 2021

a sky . a sea .distant mountains . horses . spring
sadie coles hq, london
april 11 – may 22, 2021

a rainbow . a nude . bright light . summer
kamel mennour, paris
june 2 – august 31, 2021

a low sun . golden mountains . fall
galerie krobath, vienna
november 4 – december 22, 2021

DCV